IMAGES
of America

MOUNT CARMEL AND QUEEN OF HEAVEN CEMETERIES

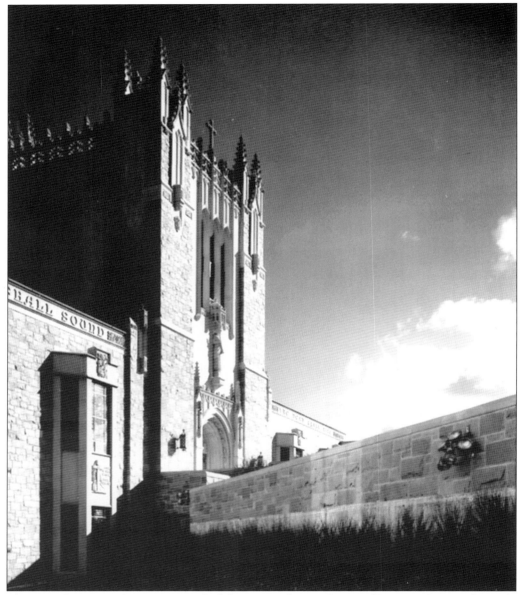

The mausoleum complex is comprised of three mausoleums: Queen of Heaven, Queen of Angels, and Queen of All Saints. Together they contain one of the world's largest collections of religious art. (Photograph courtesy of the Chicago Historical Society.)

On the cover: The photograph on the cover depicts the solemn proceedings for Archbishop James E. Quigley, the second archbishop to lead the diocese of Chicago on July 15, 1915. Completed only three years prior, the Bishop's Mausoleum located in the heart of Mount Carmel Cemetery in Hillside was constructed for just this purpose: to provide a special sanctuary for the bishops and archbishops who had served the catholic flock of the city. The limestone and marble building is draped in black bunting as mourners gather to place his body inside the crypt. The photograph appeared in the Chicago Daily News. (Courtesy of the Chicago Historical Society.)

IMAGES
of America

MOUNT CARMEL AND
QUEEN OF HEAVEN CEMETERIES

Jenny Floro-Khalaf and Cynthia Savaglio

ARCADIA
PUBLISHING

Published by Arcadia Publishing
Charleston SC, Chicago IL, Portsmouth NH, San Francisco CA

Printed in the United States of America

Library of Congress Catalog Card Number: 2006921467

For all general information contact Arcadia Publishing at:
Telephone 843-853-2070
Fax 843-853-0044
E-mail sales@arcadiapublishing.com
For customer service and orders:
Toll-Free 1-888-313-2665

Visit us on the internet at http://www.arcadiapublishing.com

My involvement in this project has provided a constant reminder about the continuity and importance of family, so I would like to dedicate this book to mine: the Savaglio family, particularly our matriarch, my mother Caroline Savaglio, on whose rock we have all built our foundation.
—Cynthia Savaglio

I dedicate my efforts in this project to my children and their posterity. It is my hope as they venture into these silent cities that they will feel the awe and be inquisitive to ask who, what, where, when, how, and why.
—Jenny Floro-Khalaf

CONTENTS

ACKNOWLEDGMENTS

None of this would have been possible without the help of the following people and organizations, whose contributions we gratefully acknowledge.

Thanks to Rob Medina of the Chicago Historical Society, Julie Satzik of the Archdiocese of Chicago Archives, Pat Bakunas of the University of Illinois Chicago Library—Special Collections, Jeanette Callaway of the Chicago Crime Commission, Catholic New World, Mount Carmel Sisters of Charity B.V.M. in Dubuque, Iowa, the Godfrey Memorial Library, the Chicago Public Library, the *Chicago Tribune*, and the *New York Times*.

Thanks to Shirley Slanker and Larry Godson of the Franzosenbusch Heritage Society, Carol Bibly of the Hillside Historical Society, Mayor Joseph Tamburino and Village of Hillside, the Hillside Public Library, Karl Sup of the Eastland Memorial Society, Eric Morgan of the Our Lady of the Angels Memorial, and Bruce Moffat for his extensive collection of information regarding the funeral train.

Heartfelt thanks go to Mario Gomes, for his unwavering friendship and extensive knowledge of the Chicago Outfit; Rose Keefe and the Estate of Dean O'Banion; Neal Trickle; Rick Mattix; the Goddard Collection; and Mari Abba, a woman who truly knows where all the bodies are buried.

Thanks to Dan Yuska of the Chicago Bears Archives, Pete Hassen of the Chicago Blackhawks, and Ron Vesely of the Chicago White Sox.

Thanks to Caroline Savaglio, Dominic Candeloro, Betty McMahon, Jeff Bertacchi, Mike Bruno, Grace Lancieri-Olivo, Rose Marie Floro, Rose (Sipari) Dapper, Christopher Botti, Karen Lynch, Phillip L. Floro, Donna Rubicz, Victoria Floro, JoAnne Floro, Faye Wilkins, Elsa Mejia, Lisa Perkins, Carol Ejzak, Ruth Lommatzsch, Alice Mroz, Kelly Kennedy, Rachel and Ryan Holzrichter, Kyle and Debra Rogers, Dena Widseth, Deanna Wassom, Emilia (Picicco) Gaglio, Irene Roman, Marge Lynch, and Toni Filler.

Special thanks to my children Mary, Susie, Michael, and Katie Khalaf, also known as my bone-yard buddies, who have spent countless hours hunting down locations.

INTRODUCTION

Call me odd, but I love cemeteries. Some of my most peaceful childhood memories have come from feeling my father's strong hand, encircling mine, as he led me past the family mausoleums, ornate statuary, and solemn monuments that comprise Mount Carmel and Queen of Heaven Cemeteries. Over the many years of visiting these two cemeteries, I have been witness to many sights. I have seen old women, clad in black clothing, beating at the ground in anger for entombing someone dear to them. I have seen young children weeping for their parents, who were taken away from them far too soon. I have seen families who still keep a Sunday vigil at the grave of a loved one, year after year, unable to fully let go.

This was common in the days when those sons and daughters of immigrants, such as my parents, would follow the traditional Italian custom of spending Sunday afternoon or religious holidays with those members of our family who had passed on to a better place. During those visits, my mother used to be fond of saying, "If these people could get up and talk, oh the stories they would tell! Can you imagine what their lives were like?"

Tragically, when I was 10 years old, I lost my older sister who is now interred at Queen of Heaven. From that point on, visiting the cemetery has taken on a deeper meaning for me, because it was then I knew that each of these headstones represented not only a life, but a story. From my perspective, each of these monuments and markers provide a small chapter in depicting the triumphs and the struggles of a community. Therefore, it is in that spirit that I hope the following pages unfold. For years I have been collecting photographs and stories that provide a variety of perspectives, both historical and current, about the lives represented in these cemeteries. While I acknowledge that in these short pages it may not reflect the entire picture, I know that some of the colors of this beautiful mosaic will emerge.

—Jenny Floro-Khalaf

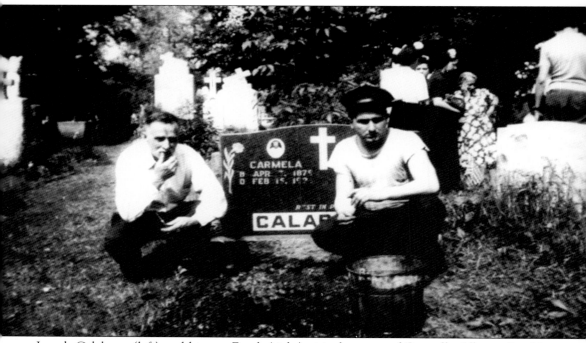

Joseph Calabrese (left) and his son Frank (right) visit the grave of Carmella Albano, Frank's mother, in 1944. (Courtesy of Stephanie Mainock.)

One

THE FORMATION

The year 1900 marked the last year of the Victorian age and the birth of the 20th century. Seventy years after being built from the ashes of a devastating fire, the city of Chicago was poised to take its place as one of the world's great cities. A boom in agriculture and manufacturing made the construction of Chicago's Loop District possible, an area that featured towering buildings on the city's once flat landscape. With the recent construction of the Masonic building, which shot into the sky a dizzying 21 stories, only New York could rival the majesty of the concrete canyons that now hugged the southern shores of Lake Michigan. Yet by 1900, with a population of almost 1.7 million inhabitants, the city had swelled to fill an area that marks its current borders. Early in the 20th century, 90 percent of that population lived in the central part of the city, with some neighborhoods sporting a density of 73,000 inhabitants per square mile. With several completed public works projects, expanded roads, and modes of public transportation, this marked the beginning of Chicagoans' turn to the west: more room to expand business, more room to build housing, and expanded memorials to honor and bury the dead.

Previous to Chicago's incorporation in 1833, families would bury their dead on their own property. Unfortunately, as families moved and land was reallocated, long forgotten graves would surprise new developers, who would accidentally stumble across them while excavating land for new construction. In 1835, the town fathers ordered that two tracts of land be set aside to create cemeteries; one for Catholics and one for Protestants. Still, these provided only temporary solutions as over the course of the intervening decades several new cemeteries would be needed for an ever-expanding population. Unfortunately, by 1900, even these newly allocated grounds would prove inadequate. Just as the living were eyeing the land west, so was the Catholic Diocese. Thanks to a rising immigrant population, which first saw Germans and Irish, and now Poles and Italians, the need to find suitable land to expand its overcrowded cemeteries was quite dire. In 1895, Archbishop Patrick A. Feehan authorized the purchase of Buck Farm, a 160-acre wooded slope located in the western suburb of present-day Hillside. In 1900, Mount Carmel Cemetery marked its inception with a dedication service. The original site consisted of 32 acres.

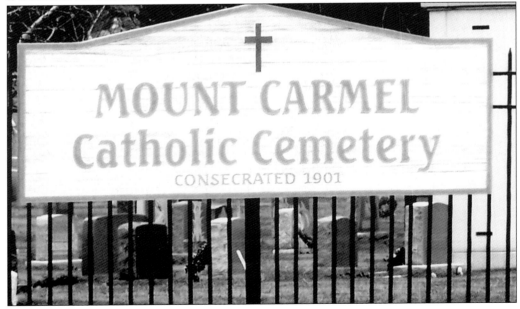

Mt. Carmel Cemetery

Consecrated 1900

A small mystery surrounds the Mount Carmel dedication ceremony that was held on August 31, 1900. There are scant accounts documenting the event, only personal observations by those who were in attendance. The Most Reverend Patrick A. Feehan, Chicago's first archbishop, presided over a ceremony of an estimated 300 attendees. One observer, the nephew of the original landowner, recalled that no oils were used at the dedication. Yet there is conflicting evidence as to when the ground was consecrated. The above sign is located at the Harrison Street entrance. It indicates that the consecration took place in the cemetery's first year, yet other records show that the ground may not have been consecrated until the following year. The photograph below is located at the corner of Roosevelt and Wolf Roads. (Courtesy of Jeff Bertacchi.)

MOUNT CARMEL
Catholic Cemetery
CONSECRATED 1901

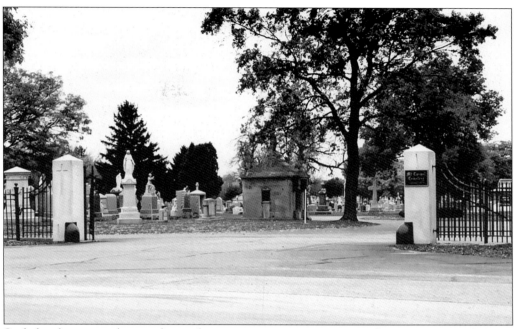

Sealed in by a wrought iron fence, there are two main entrances to the 214-acre site of Mount Carmel. The Harrison Street entrance is pictured here.

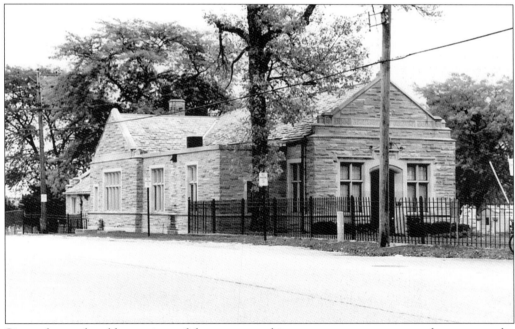

Situated near the older sections of the cemetery, this stone structure was erected to serve as the business office for Mount Carmel. This cemetery maintained its own office until around 1965, when it merged with Queen of Heaven, leaving this building to serve as a public restroom.

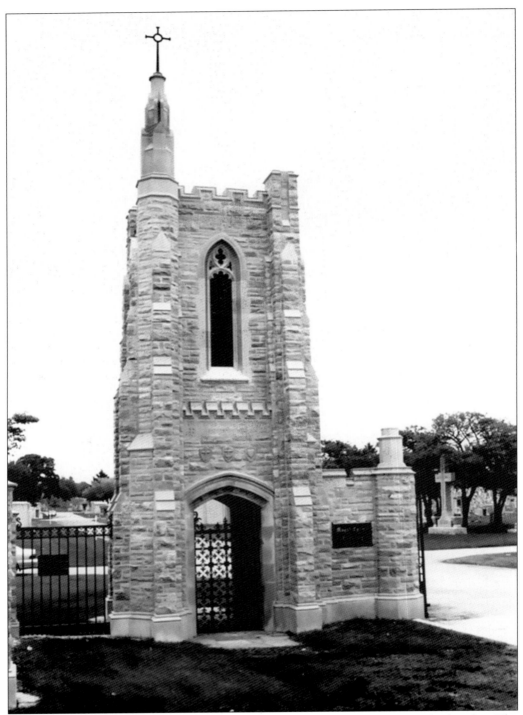

This brick and stone edifice was built to resemble the cathedrals of the area's early churches. The earliest sections of the cemetery are separated by letters of the alphabet, but by 1911, so many had been buried at Mount Carmel that numbers had to be instituted.

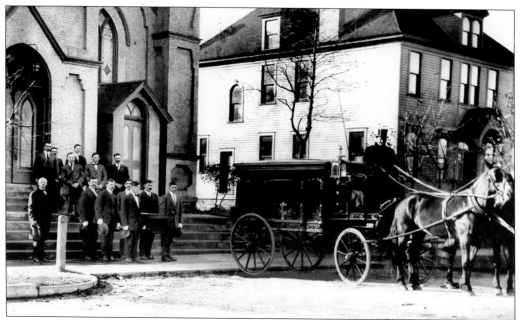

For the first six years of the cemetery's existence, mourners had to mount a horse-driven procession from the city to Mount Carmel, like the one pictured here from Conboy Funeral Home, around 1885. A trip of over 15 miles on scantily paved roads would make this journey take an entire day. They still own the carriage pictured here and continue to take it out for special community celebrations. (Courtesy of Conboy-Westchester Funeral Home.)

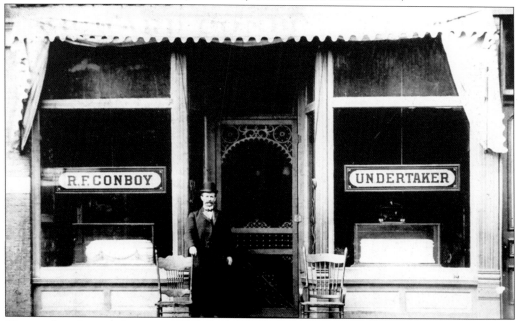

This is what the storefront to Conboy Funeral Home looked like in 1885 when it was located on Grand Avenue. Now called the Conboy-Westchester Funeral Home, it has relocated to Cermak Avenue in Westchester. (Courtesy of Conboy-Westchester Funeral Home.)

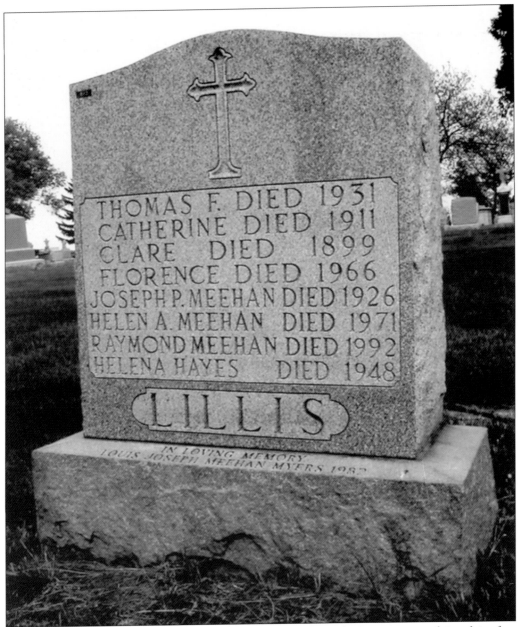

THOMAS F. DIED 1931
CATHERINE DIED 1911
CLARE DIED 1899
FLORENCE DIED 1966
JOSEPH P. MEEHAN DIED 1926
HELEN A. MEEHAN DIED 1971
RAYMOND MEEHAN DIED 1992
HELENA HAYES DIED 1948

LILLIS

IN LOVING MEMORY
LOUIS JOSEPH MEEHAN MYERS 1982

Almost four weeks before the ground was officially dedicated, the cemetery claimed its first interment, little Clare Lillis who passed away in the first year of her life. In point of fact, the cemetery would open with a most heartbreaking debut as the first five interments were all children. Early in the 20th century, the infant mortality rate in Chicago was approximately 130 per 1,000 live births. Children had a 75 percent chance of reaching the age of five (these are estimates based on death rates, in 1900, specific health statistics were not recorded). However, as the local government pushed to increase sanitary conditions with the building of parks, paving of streets, and the institution of waste management systems, health conditions would make slow but steady improvement.

INTERMENTS
9/16-15
6/13/18
10/28/18
4/7/25

Mount Carmel Cemetery 116

City Office: 107 N. Dearborn St., Rooms 32 & 33

NO WOODEN OR IRON
CROSSES PERMITTED

Chicago, Nov 19th 1912

Received from Leonardo Separi

Ten ————————————— Dollars for the following described grave in

MOUNT CARMEL CEMETERY

Grave No. 52 · 50 Block No. 23 Section 0

Opening Grave, $ 3 00

Box - - $ 4 00

Total - $ 10 00

D K Kinsella
Superintendent

Four small Children, or an Adult and two small Children, only can be interred in this Grave.
Removals from the Vault for interment are not permitted on Sundays.

Telephones { Cemetery, Maywood 935
{ City Office, Central 5007

MT. CARMEL CEMETERY,

95 DEARBORN STREET, Rooms 32 and 33.

NO WOODEN OR IRON
CROSSES PERMITTED

Chicago, Feb 4 1908

RECEIVED OF Gerardo Separe

Five ————————————— Dollars for the following described grave in

MOUNT CARMEL CEMETERY.

Grave No. 67 Block No. 3 Section 0

Opening Grave, - $ 1 00

Box, - - - $ 1 00

Total, - - - $ 7 00

D K Kinsella
SUPT.

Four small Children, or an Adult and two small Children, only can be interred in this Grave.
Removals from the vault for interment are not permitted on Sundays.

Initially, to purchase a plot could cost as little as $5. In 1918, it doubled to $10 a year, due to the Spanish Influenza epidemic, which would make such a purchase all too commonplace. Depending on the section, graves could be found in 30-inch, 33-inch, or 36-inch widths. (Courtesy of Rose [Sipari] Dapper.)

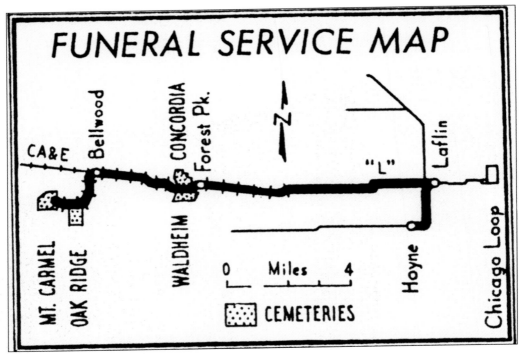

FUNERAL SERVICE MAP

CA&E
Bellwood
CONCORDIA Forest Pk.
"L"
Laflin

N

MT. CARMEL
OAK RIDGE
WALDHEIM
Hoyne
Chicago Loop

0 Miles 4

▨ CEMETERIES

Metropolitan "L"

FUNERAL CAR SERVICE

For Particulars apply to your Local Undertaker, or
Telephone Harrison 3775 or West 879

Due to the popularity of streetcar service in the central part of the city, officials for the Metropolitan West Side Elevated Railway thought they would take a gamble on what was a radical idea in 1905. They were well aware of the difficulties of traveling to the western suburbs via horse and wagon, so why not offer a railway car specifically outfitted for the purpose of transporting a funeral procession? At its inception, the idea was roundly criticized. Many thought it an undignified form of passage for so solemn an occasion. Nevertheless, the overwhelmingly positive response by the public quickly silenced the voices of the detractors. The original Met service went to Waldheim and Concordia Cemeteries in Forest Park. The following year it expanded to include Mount Carmel. (Courtesy of Bruce Moffat.)

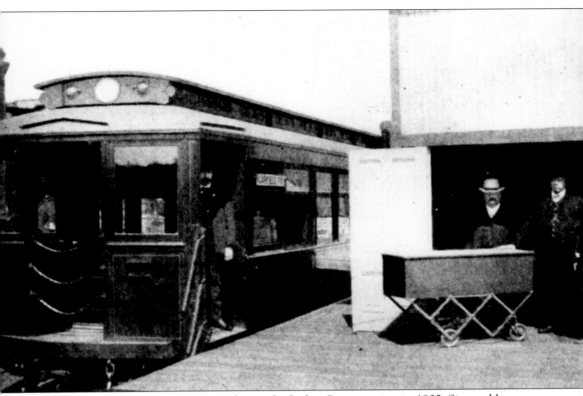

Car No. 802 stands by to receive a casket at the Laftin Street station in 1905. Situated between Jackson Boulevard and West Congress Street, the Laftin Street station was located on the main elevated rail line. At the center of the train platform, a special elevator large enough to hold a casket was built. Once secured in the specially designed forward compartment of the car, a party of up to 34 mourners could be comfortably seated in the remaining parlor. Eventually casket elevators were installed at the Hoyne and Douglas stations. The Met advertised that it would receive funerals at any of its stations located on the main line, forcing pallbearers to make a rather winded journey up several flights of stairs with casket in tow. (Courtesy of Bruce Moffat.)

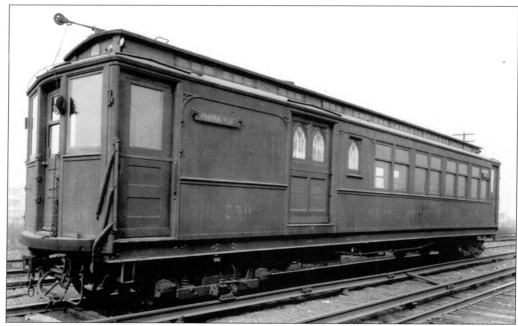

There were eventually four cars outfitted for this very unique service. The 2756, later named the 756, is pictured here. A trip to the west side cemeteries, including Mount Carmel, would have taken between 30 to 40 minutes. Charter service for funeral transportation was $30 for a funeral party of up to 45 persons. One funeral car could make several trips per day and transport two caskets if needed. (Courtesy of Bruce Moffat.)

Located on Roosevelt Road, the Mount Carmel Station, pictured here, was the final destination for those scheduled to be interred at Mount Carmel Cemetery. Passengers in funeral parties were given return trip tickets with the option of riding on regular passenger trains. By October 1907, the service reported that it was handling an average of 22 funerals per week. (Courtesy of Bruce Moffat.)

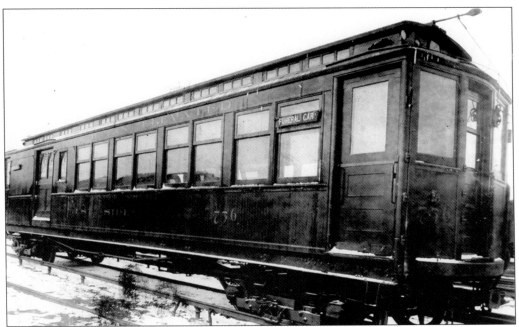

Roosevelt Road was the first street in Illinois to be paved with concrete. Thus came the automobile, and with it, the demise of the service. The last train funeral occurred on July 13, 1934, and with that the era of the funeral train had come to an end. Put up on blocks, the 756 saw a brief respite as a medical facility and was eventually scrapped. (Courtesy of Bruce Moffat.)

This photograph from around 1900 depicts the greenhouse of R. O. Lommatzsch, one of the early area businesses that expanded from its original roadside stand. (Courtesy of the Hillside Historical Society.)

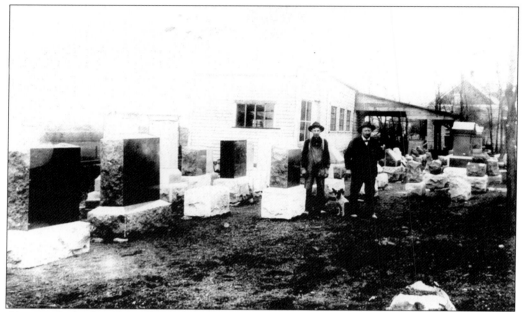

Along with the founding of the cemetery, so too came the establishment of businesses that would service Hillside's burgeoning funeral trade. Florists, greenhouses, and monument companies started to flourish in the area. One of the early companies, Boese Monuments, was located on Oakridge Avenue. This is a c.1900 photograph. (Courtesy of the Hillside Historical Society.)

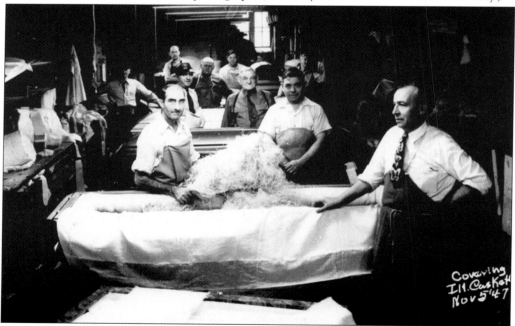

Workers at the Illinois Casket Company are processing a special-order coffin. This photograph was taken on November 5, 1947. The business was located at 2330 Van Buren Street, on the corner of Western Avenue. (Courtesy of the University of Illinois at Chicago; the University Library, Department of Special Collections—Italian American Collection.)

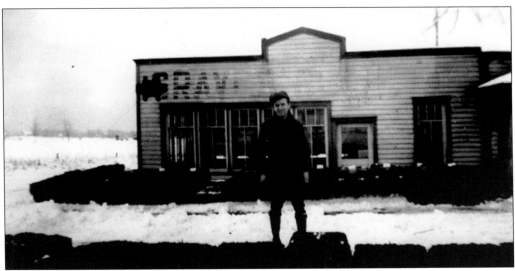

Established in 1929, one of the more enduring companies located near Mount Carmel on Wolf Road is Bertacchi and Sons Monument Company, founded by Armando Bertacchi on February 6, 1929. His son Aldo Bertacchi, who is pictured above in a 1942 photograph, made it a family affair to provide some of the more elaborately designed mausoleums and statuary that adorn the cemetery. The photograph below is a snapshot of how the building that houses the business looked in 1943. They are still doing business at the same location. The company is currently being run by the third and fourth generations of Bertacchis. (Courtesy of Bertacchi and Sons Monument Company.)

Because the trip to Hillside could sometimes take the entire day, eateries also popped up near the cemetery. First there were the Irish taverns, like Murphy's Place, later known as O'Rourke's, and subsequently Moran and Galvin's. An advertisement is pictured here, sporting a rather enviable meal price by today's standards.

With the original family business dating back to 1870, Peter Troost Monuments, as seen here in 1943, moved to the Roosevelt Road location in 1911. It has been a family-owned business for five generations. (Courtesy of Peter Troost Monument Company.)

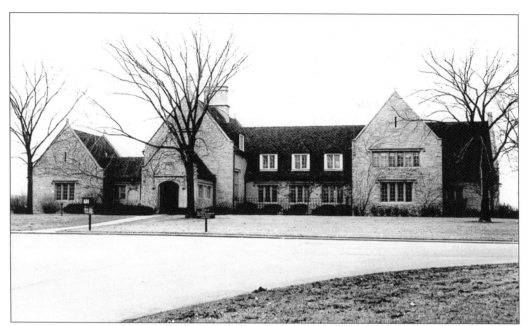

Pictured above, the office is located on the grounds of Queen of Heaven just inside the Wolf Road entrance. It houses the business affairs of both Mount Carmel and Queen of Heaven Cemeteries. (Courtesy of the Archdiocese of Chicago Archives.)

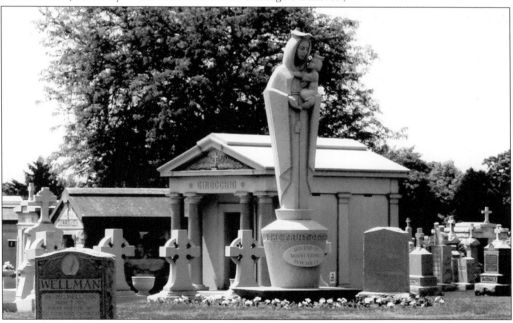

Located inside the Harrison Street entrance stands the Shrine to Our Lady of Mount Carmel on the Mount Carmel cemetery grounds. The name Mount Carmel is derived from the order of the Carmelite nuns that was established in the 14th century. Our Lady of Mount Carmel is an extremely important religious figure in the lives of the Italian immigrants whose families make up one of the majority groups represented here.

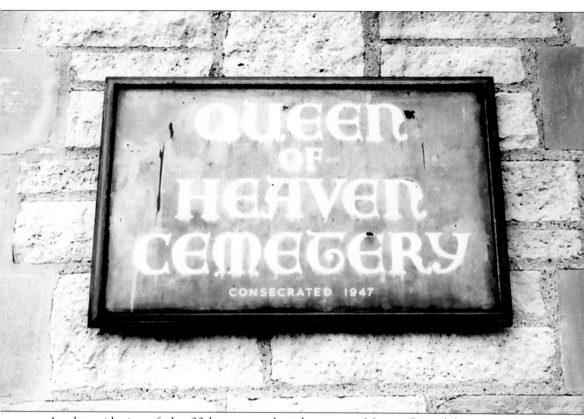

At the midpoint of the 20th century, burial space at Mount Carmel began to dwindle. Consequently, the 472 acres across Wolf Road from Mount Carmel became one of the country's first modern cemeteries. Consecrated in 1947, Queen of Heaven Cemetery was a trailblazer in the development of religious shrines and shared family memorials. It sports the largest catholic indoor mausoleum, the Queen of Heaven Mausoleum, which contains 30,000 crypts. Located on the same grounds is the beautifully designed Christ the King Garden Mausoleum that contains over 20,000 crypts.

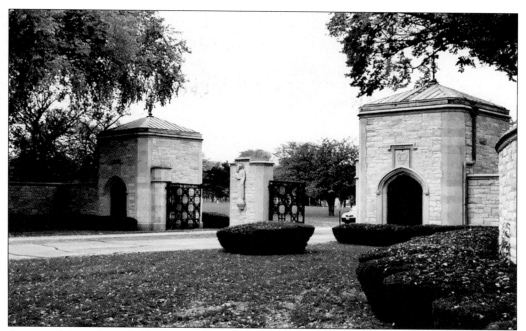

As one drives through the main entrance, located off Wolf Road, it is apparent by the predominance of the cathedral-like stone structures, the abundant statuary, and a restful garden setting that great care has been taken to make this a place of serenity and reverence.

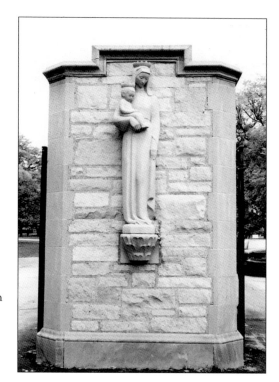

This is a closer look at the statue that adorns the entrance. The figure of the Blessed Virgin and Christ Child provides a thematic motif that is created in many forms throughout the cemetery. This beautiful piece of art was carved from granite by Sylvia Shaw Judson (1897–1978), who was from Lake Forest.

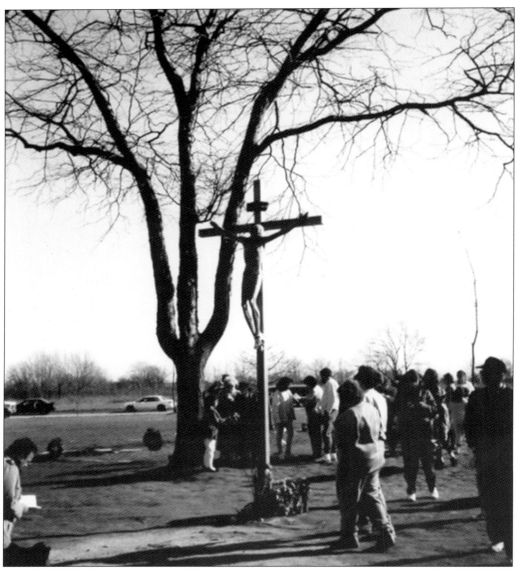

There is one place on the grounds of Queen of Heaven that has gained fame as a reported site of miracles. Returning from a pilgrimage to a religious shrine in Bosnia-Herzegovina, 80-year-old Joseph Reinholtz had been the recipient of a healing. Blind, he could now see. A religious mentor instructed him on his return home that he should find a crucifix placed between two trees, one of which should have three branches. His vision led him to this spot on the grounds of Queen of Heaven. In his prayers, Reinholtz claims to have seen visions of Our Lady and St. Michael. There have also been reports of the crucifix oozing blood and rosaries turning to gold. Once his story became public in 1991, thousands of pilgrims flocked to the site. Unfortunately, the crowds became so numerous that people started trampling burial plots and pulling bark off the adjacent tree. In 1992, the archdiocese moved the cross from its original location, pictured here, to one that is 300 yards away, complete with a shrine and ample parking. Sadly, this did not stop the destruction, as vandals desecrated the crucifix by chopping off Jesus's feet. Joseph Reinholtz passed away on December 18, 1996. (Courtesy of Rose Marie Floro.)

Two

THE BISHOP'S CHAPEL

The Bishop's Chapel sits atop the highest peak inside the walls of Mount Carmel Cemetery. Chicago's most ornately adorned structure, it houses an exclusive and most reverend population—the cardinals, bishops, and archbishops of the diocese of Chicago. The design stage began in 1903, and construction began on July 5, 1905, with a groundbreaking ceremony. It was not completed until nine years later in 1912. It was the brainchild of Chicago's second archbishop, James Quigley, who oversaw its construction. He engaged a local architect, William J. Brinkman, who came up with the simple, Romanesque style that embodies the building's outline. However, in keeping with the aesthetic tastes of his predecessor, Patrick Feehan, Quigley engaged one of the most famous religious architects of the day, Aristide Leonori, who designed the building's breathtaking interior. Famous for his designs of Mediterranean cathedrals in the early part of the 20th century, Leonori executed a design reminiscent of Rome in marble and mosaic. However, in a city as diverse as Chicago, it was important to insure that the ethnic array within the Catholic community was also represented in the mausoleum's artwork. Therefore saints representing Celtic, Nordic, and Slavic traditions are depicted with those that are Latin in origin. Marking the history of the diocese through those who have most notably served it, the chapel is rich in religious symbolism. A symbolism that is best summed up by the words inscribed around the Risen Christ, depicted above the altar: "Remember those Prelates who have spoke the word of God to you. Whose Faith follow, consider the end of their conversation."

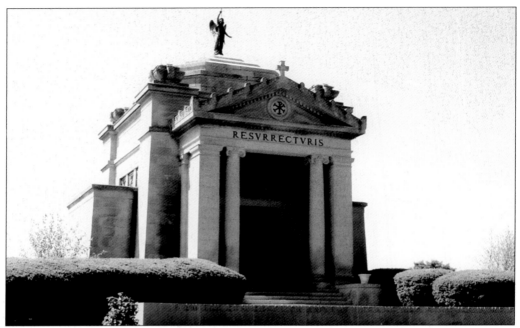

Constructed of Bedford limestone, the main feature of the Bishop's Chapel is the bronze statue perched atop the building's dome. It depicts the Angel of the Resurrection, a perpetual reminder of the cornerstone on which Catholicism is based. There are 30 steps leading up to a pair of carved bronze doors. Above this entrance a single word is engraved, *Resurrecturis*, which means "to those who will rise again."

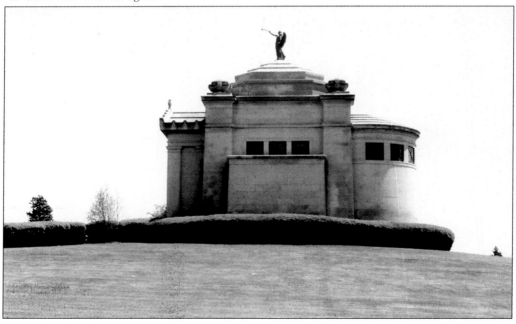

The Risen Christ adorns the area just above the altar. Comprised of a mosaic that was designed in Italy, pasted on paper, and then shipped to the United States, four Italian workers were hired to reconstruct a panorama that outward from Christ depicts the dead rising from their tombs. The interior is constructed of marble, fashioned after designs taken from the catacombs in Rome and mosaics found in Venice. High above the altar is the scene from the Last Supper depicting Jesus washing the feet of his disciples. The scene is a symbolic reminder to the prelates buried here of their solemn duty as servants of God.

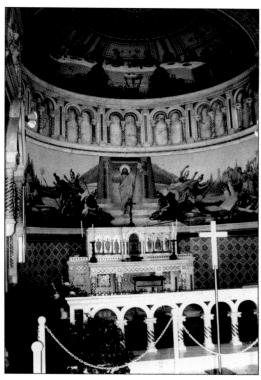

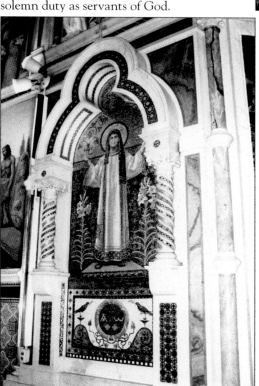

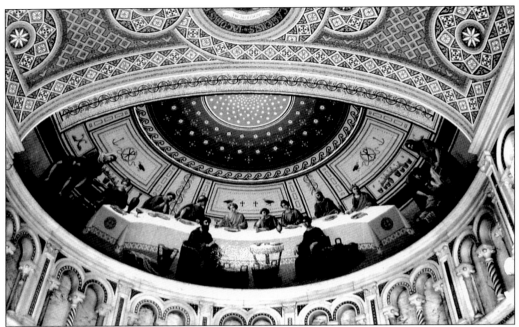

Here is a closer view of both the *Good Shepard* and the *Last Supper* mosaics. Symbolic of the prelates' service to their flock, the *Last Supper* depicts Christ washing the feet of the 12 disciples. The *Good Shepard* mosaic is a reminder of the bishop's responsibility to provide leadership through example.

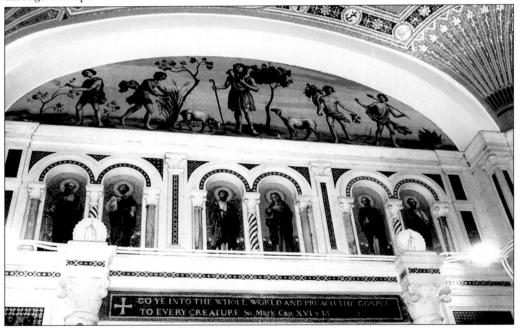

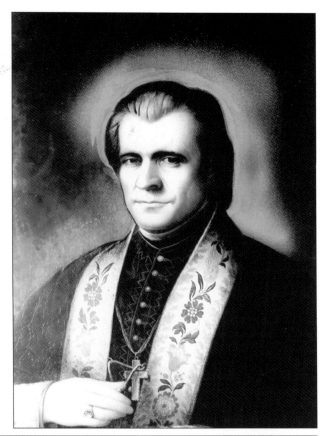

Bishop William J. Quarter was born in Killurine, King's County, Ireland, in 1806. Heeding the call for missionary priests, he was ordained in New York. With an emphasis on creating educational institutions, Reverend Quarter attained the office of bishop. He was appointed to his position as Chicago's first bishop shortly after Pope Gregory XVI designated the entire state of Illinois as the new Diocese of Chicago. He inherited a vast territory mostly comprised of prairie farming communities. He served from 1844 until his death on April 10, 1848. He is interred in the Bishop's Chapel at Mount Carmel. (Courtesy of the Archdiocese of Chicago Archives.)

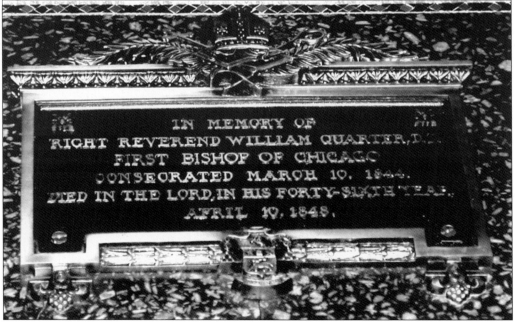

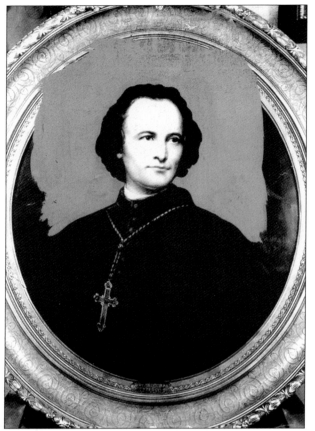

The prelacy of Bishop James Duggan, born on May 22, 1825, was defined by one of the country's most challenging eras—the Civil War. Due to the troubling times in which he served the community, Bishop Duggan started to withdraw more and more, serving the diocese in name only. After a 29-year bout of mental illness, ill health claimed him on March 27, 1899. However, unlike his predecessors, due to less liberal views regarding mental health in the early days of the cemetery, his body was not moved to the Bishop's Chapel. He remained buried at Evanston's Calvary Cemetery and was brought to the Bishop's Chapel in 2001. (Courtesy of the Archdiocese of Chicago Archives.)

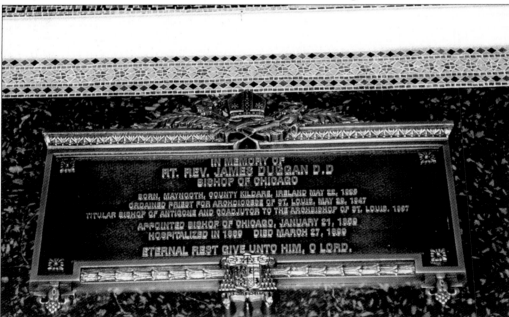

IN MEMORY OF
RT. REV. JAMES DUGGAN D.D
BISHOP OF CHICAGO

BORN, MAYNOOTH, COUNTY KILDARE, IRELAND MAY 22, 1825
ORDAINED PRIEST FOR ARCHDIOCESE OF ST. LOUIS, MAY 29, 1847
TITULAR BISHOP OF ANTIGONE AND COADJUTOR TO THE ARCHBISHOP OF ST. LOUIS, 1857

APPOINTED BISHOP OF CHICAGO, JANUARY 21, 1859
HOSPITALIZED IN 1869 DIED MARCH 27, 1899

ETERNAL REST GIVE UNTO HIM, O LORD.

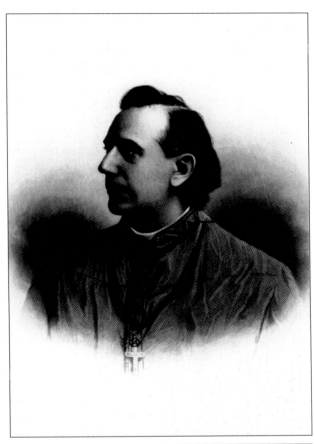

Another son of Ireland, Archbishop Patrick Augustine Feehan was born on August 28, 1829. Father Feehan's ministry was marked with tragedy and triumph. He served as a chaplain during the Civil War. From Shiloh to Mission Ridge, he was on the frontlines of some of the war's bloodiest conflicts. He was elevated to Chicago's first archbishop in 1880, inheriting a parish in ruins shortly after Chicago's Great Fire. His numerous good works included the founding of hospitals and orphanages, and the expansion of Catholic education. He officiated at the dedication of Mount Carmel shortly before his death on July 12, 1902. (Courtesy of the Chicago Historical Society.)

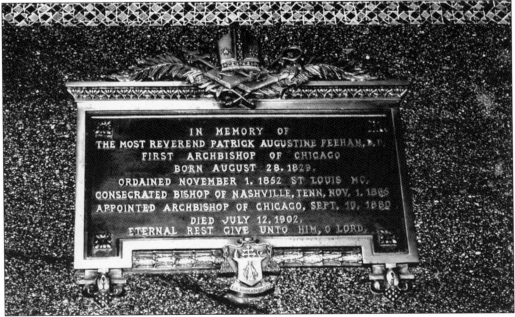

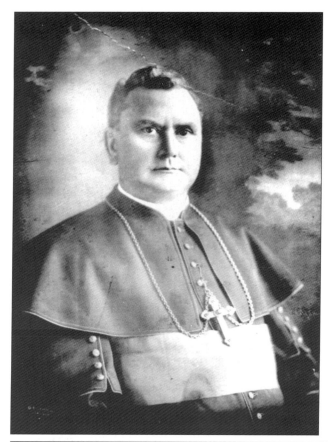

Chicago's second archbishop was born on October 15, 1854, in Ontario, Canada. Archbishop James Edward Quigley reversed the precedent set by previous Chicago ordinaries who were born in Europe and ordained in the United States with his ordination in Rome in 1879. He was installed as archbishop in 1903. Thanks to an explosion of immigrant Catholics, Reverend Quigley ushered in the foundation of 75 new churches. With each new church construction, he had the foresight to provide for a new parochial school. While his administration was relatively short—only 12 years—it also saw the opening of Cathedral College and Loyola and DePaul Universities. He died in Rochester, New York, on July 10, 1915. (Courtesy of the Chicago Historical Society.)

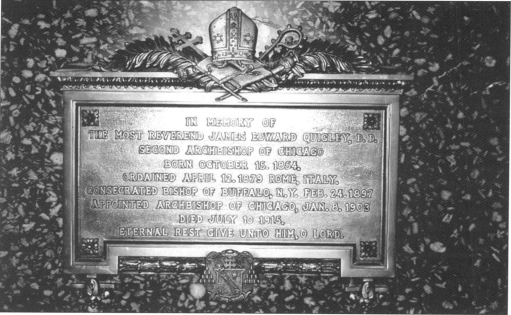

IN MEMORY OF
THE MOST REVEREND JAMES EDWARD QUIGLEY, D.D.
SECOND ARCHBISHOP OF CHICAGO
BORN OCTOBER 15, 1854,
ORDAINED APRIL 12, 1879 ROME, ITALY,
CONSECRATED BISHOP OF BUFFALO, N.Y. FEB. 24, 1897
APPOINTED ARCHBISHOP OF CHICAGO, JAN. 8, 1903
DIED JULY 10 1915,
ETERNAL REST GIVE UNTO HIM, O LORD.

The fourth archbishop of Chicago, Samuel Cardinal Stritch, was the leader of the Chicago diocese for almost 19 years. Due to his diligent works in fighting fascism and supporting minority civil rights, the Pontiff, Pope Pius XI, had named him to a diplomatic post in the Roman Curia. He was the only American to ever be named as part of the church's central administrative body. He died in Rome after a stroke at age 70 on May 27, 1958. His body was returned to Chicago where, during a three-day vigil, over a quarter-million mourners filed past to pay their respects. Countless others watched the telecast of the funeral through WGN-TV. The beginning of the procession is pictured here, where thousands lined the streets to see the passing funeral cortege. (Courtesy of the Archdiocese of Chicago Archives.)

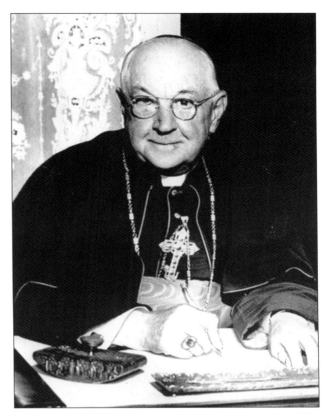

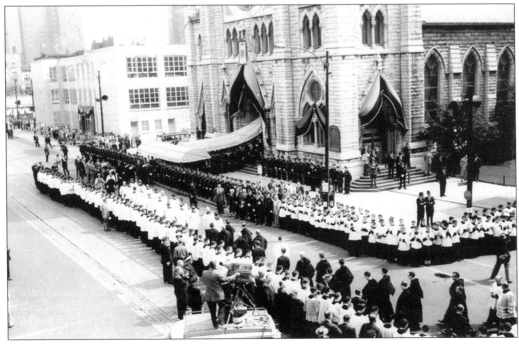

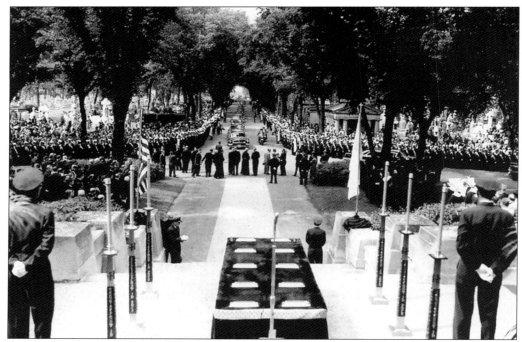

One hundred seventy automobiles followed Cardinal Stritch's hearse to Mount Carmel, while an honor guard comprised of policemen, firemen, nurses, and the Knights of Columbus lined the last mile of the procession. Twelve priests carried the casket and placed it upon a black catafalque flanked by six lighted candles. Bishop Hillinger, seen here preceding the casket, officiated the cemetery rites. (Courtesy of the Archdiocese of Chicago Archives.)

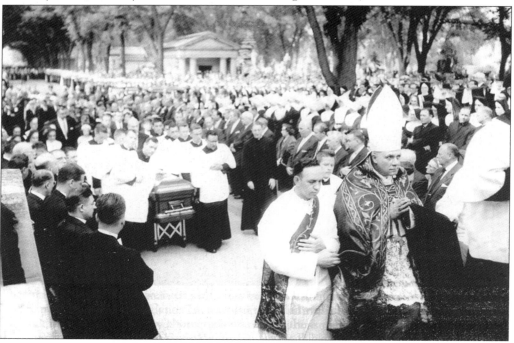

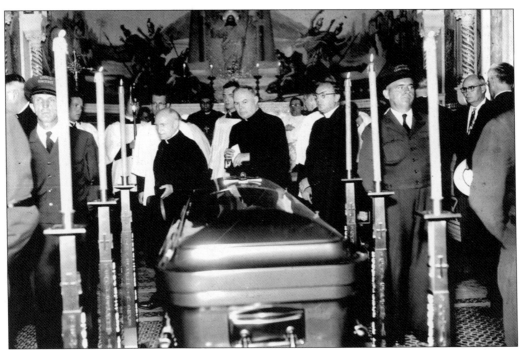

Bishop O'Connor (center) pays his last respects to Cardinal Stritch. The casket is placed in an individual crypt feet first, and the crypt is then sealed. It takes several months for the bronze plaque to be made and set in place. (Courtesy of the Archdiocese of Chicago Archives.)

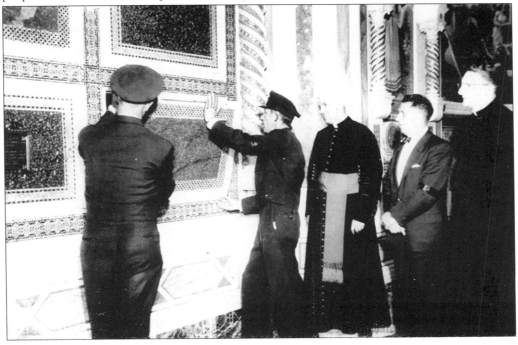

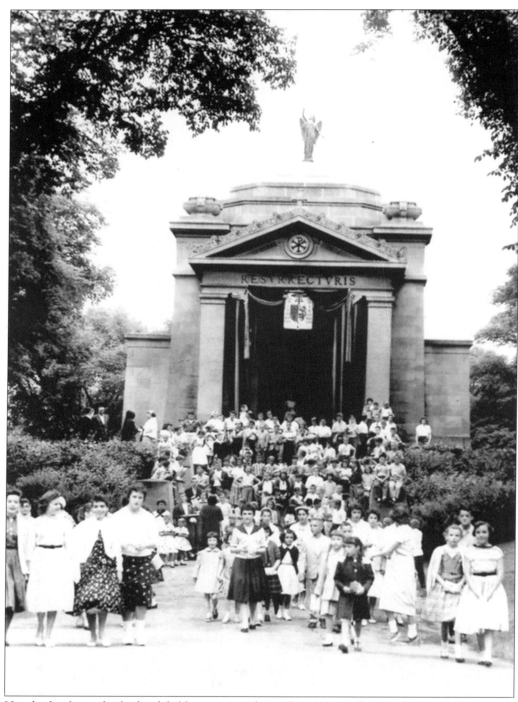

Hundreds of parochial schoolchildren are seen here after paying tribute to the late prelate in the Bishop's Chapel. From 1940 to 1958, Cardinal Stritch was credited with the construction of 75 grade schools, 12 high schools, and new buildings on the campuses of 6 Catholic universities. (Courtesy of the Archdiocese of Chicago Archives.)

Long-time president of the Catholic Extension Society, Archbishop William David O'Brien was born in Chicago on August 3, 1878, and served his entire prelacy here. Focusing on education and community service, he helped to ensure that deserving Catholic youth had the means to afford a higher education by establishing a scholarship in his name. He was an integral administrative member of the diocese, who supported the elevation of Cardinal Stritch. He was an Auxiliary Bishop of Chicago from 1934 to 1962. He died on February 19, 1962. (Courtesy of the Archdiocese of Chicago Archives.)

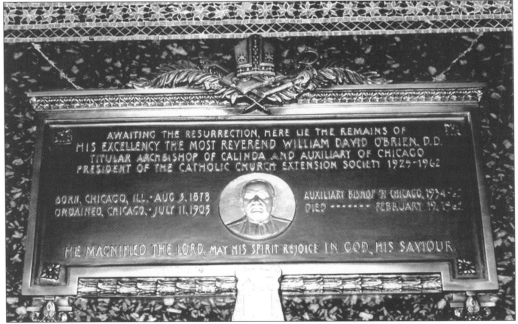

AWAITING THE RESURRECTION, HERE LIE THE REMAINS OF
HIS EXCELLENCY THE MOST REVEREND WILLIAM DAVID O'BRIEN, D.D.
TITULAR ARCHBISHOP OF CALINDA AND AUXILIARY OF CHICAGO
PRESIDENT OF THE CATHOLIC CHURCH EXTENSION SOCIETY 1925-1962

BORN, CHICAGO, ILL.·AUG 3, 1878 AUXILIARY BISHOP OF CHICAGO, 1934-
ORDAINED, CHICAGO,·JULY 11, 1903 DIED ------ FEBRUARY 19, 1962

HE MAGNIFIED THE LORD, MAY HIS SPIRIT REJOICE IN GOD, HIS SAVIOUR.

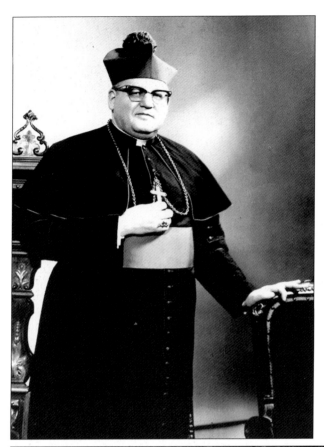

A Missouri native, John Patrick Cardinal Cody was born in St. Louis on Christmas Eve in 1907. During the dark days of Fascism, he was ordained a priest in Rome in 1931. Returning to the United States in 1938, his distinguished career of holy service took him from his native St. Louis to Kansas City and then to New Orleans before being installed as the archbishop of Chicago in 1965. Two years later, Pope Paul VI elevated him to the position of cardinal. He participated in both conclaves held in 1978 and passed away on April 25, 1982. (Courtesy of the Archdiocese of Chicago Archives.)

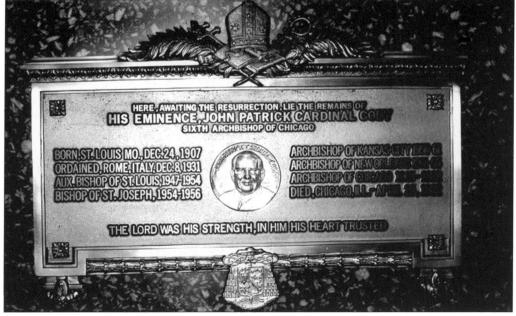

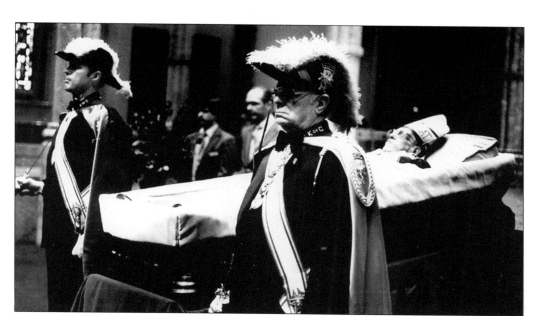

Cardinal Cody's body was dressed in white priestly vestments with his bishop's miter atop his head inside an open bronze casket that was placed on a red-draped catafalque. A 150-car procession was greeted at Mount Carmel by a crowd of more than 500 people. It is estimated that over 40,000 people visited the tomb of the late Cardinal Cody during a period of three months following his death. (Courtesy of the Archdiocese of Chicago Archives.)

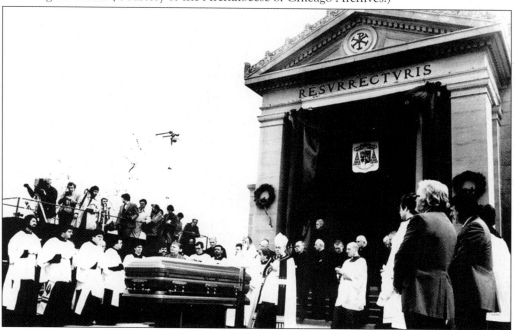

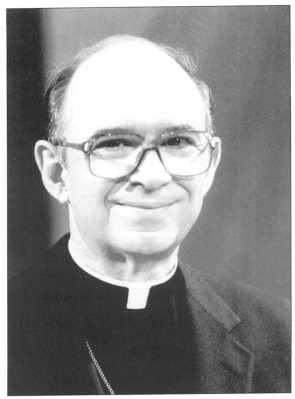

Born in Columbia, South Carolina, on April 2, 1928, this son of Italian immigrants would become one of Chicago's most beloved religious leaders. Joseph Cardinal Bernardin was ordained in 1952. He swiftly rose through the hierarchy of the church as the youngest bishop of Atlanta during the turbulent civil rights era. Being on the frontlines of the struggle for racial equality set the tone for a ministry that saw him being honored with the Presidential Medal of Freedom. In 1982, he was appointed the seventh archbishop of Chicago and elevated to the College of Cardinals by Pope John Paul II. He lost a heartbreaking battle to pancreatic cancer on November 14, 1996. During two days of mourning, over 100,000 people filed past his coffin. (Courtesy of the Archdiocese of Chicago Archives.)

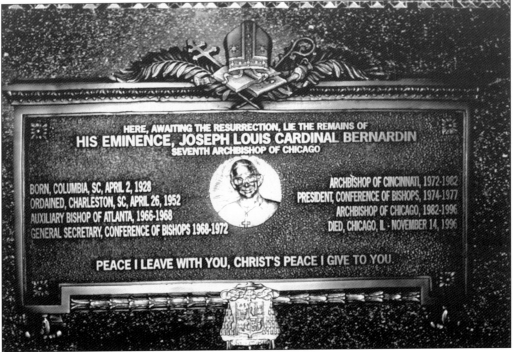

Three

THE MAUSOLEUMS

To find the origin of the mausoleum, one has to travel back to the days of ancient Greece. Known as one of the Seven Wonders of the Ancient World, it was erected by a queen in mourning as a monument to her dead husband, King Mausolus of Caria in Asia Minor. From that time on, the tomb at Halicarnassus would come to be known as a mausoleum, or a large tomb above ground. In Mount Carmel and Queen of Heaven Cemeteries, examples of this type of memorial are numerous. Due to their popularity in Europe, immigrants were the first to erect mausoleums at Mount Carmel, and there are currently over 400 of them. Yet, the most beautiful and grandiose of these structures are located at Queen of Heaven Cemetery.

Boasting the world's largest Catholic mausoleum, Queen of Heaven's mausoleum has all the elements of a grand cathedral, with small prayer chapels, marble fixtures, and stained-glass windows. The adjacent Christ the King Garden Mausoleum sports an awe-inspiring, 21-foot statue of the Savior. The atmosphere inside both of these colossal edifices was purposely designed to honor the dead, console the living, and inspire religious devotion. Inside the shrine are replicas of Lourdes, Fatima, and Nazareth. Exemplifying a mix of traditional and contemporary interpretations of the life of Christ, the mausoleum sports a dizzying array of Venetian and Florentine-style mosaics and statuary.

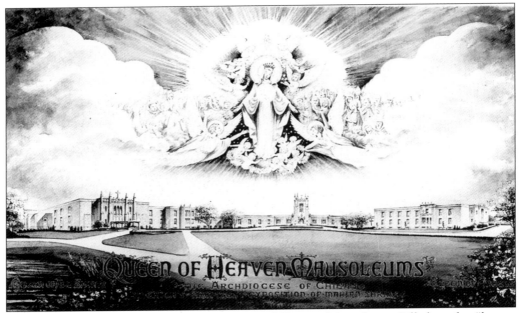

Above is an artist's rendering for the Queen of Heaven Mausoleum. Billed as the "largest Catholic mausoleum" ever built, it appeared in literature distributed by the diocese. Official groundbreaking ceremonies took place on April 4, 1956. Performing the honors was Archbishop William D. O'Brien, Auxiliary of Chicago, depicted here along with (left to right) Rev. Monsignor F. J. McElliot, archdiocesan director of Catholic Cemeteries; Rev. William J. McNichols; G. J. Klupar, executive director of Catholic Cemeteries; and Rev. Edward F. Myers. (Courtesy of the Archdiocese of Chicago Archives.)

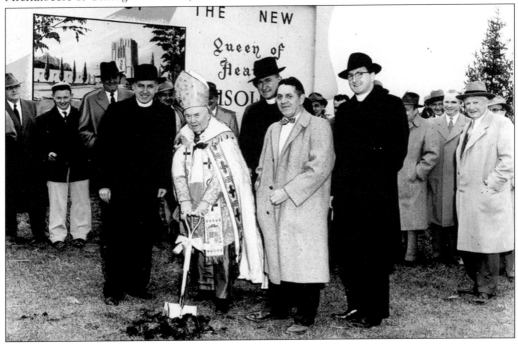

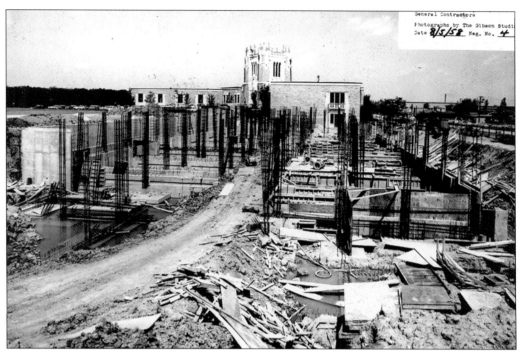

These two photographs chronicle the early stages of what became a 20-year construction project. The buildings were designed by the firm of Harley, Ellington, and Day. In order to defray costs, the diocese was able to sell many crypts while the mausoleum was still under construction. (Courtesy of the Archdiocese of Chicago Archives.)

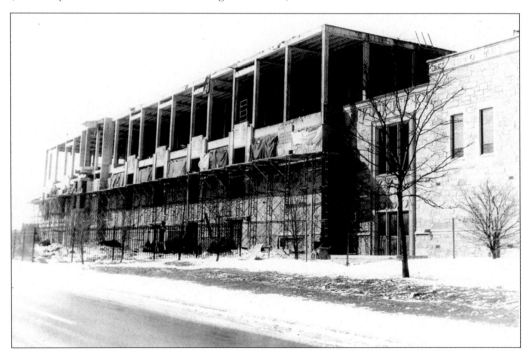

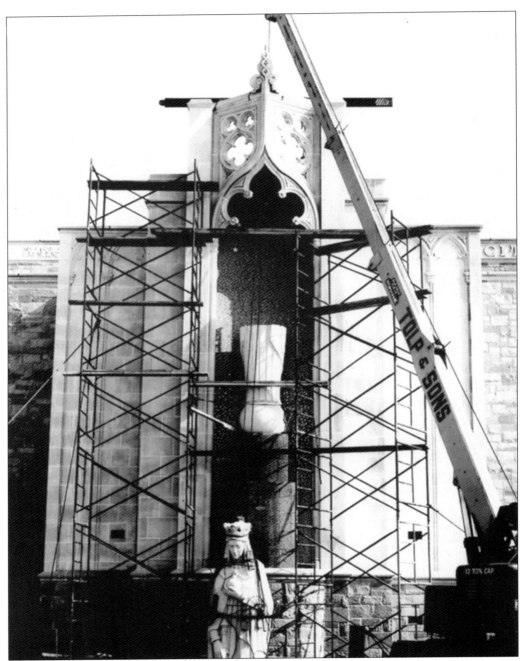

Construction of the Queen of Heaven Mausoleum involved erecting intricate statuary. Here a work crew is undertaking a rather difficult assembly of a 12-ton statue of the Blessed Virgin by placing it on a narrow pedestal located 40-feet above ground. The Queen of the Universe represents a major design feature adorning the exterior of the building. Hundreds of European artisans hand carved the statuary features located both inside and outside the mausoleum. (Courtesy of the Archdiocese of Chicago, created February 1964.)

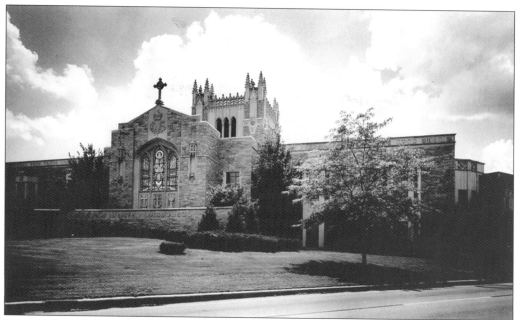

Pictured here shortly after completion, the present-day Queen of Heaven Mausoleum has grown to a 30,000-crypt capacity. The complex is comprised of three mausoleums: Queen of Heaven, Queen of Angels, and Queen of All Saints. The final building design features a stone facade and Norman-influenced details, reminiscent of European cathedrals. (Above, courtesy of the Archdiocese of Chicago Archives; below, courtesy of the Chicago Historical Society.)

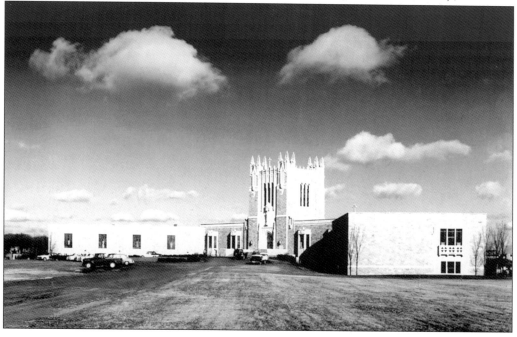

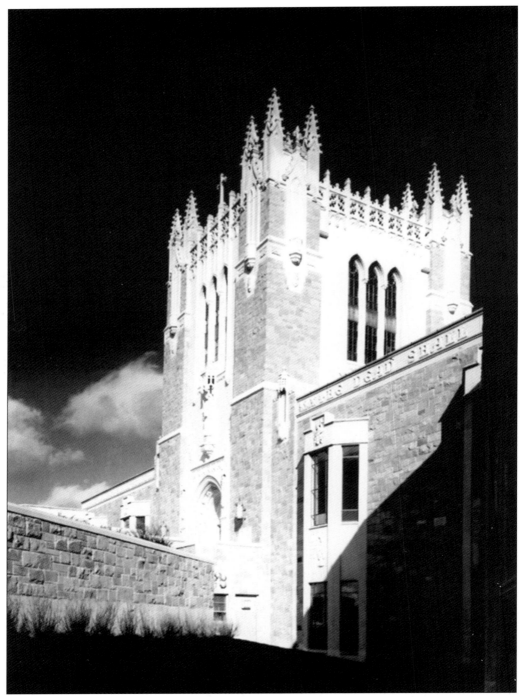

Countering medieval Norman tradition, the entrance to the Queen of Heaven Mausoleum faces west. The elongated arched windows, or triforia, adorn all four sides of the building. The buttresses, with their decorative and pointed arches, are also a variation on Norman style. (Courtesy of the Chicago Historical Society.)

In 1956, the 10-foot-tall statue of the Archangel Gabriel was lifted into place three stories above ground. It is pictured above, adorning the entrance to the mausoleum. The 10,000-pound statue took 10 weeks to carve and was the final work of sculptor August Volker prior to his retirement. In the photograph below, he supervises the statue's reconstruction prior to its installation. (Above, courtesy of the Archdiocese of Chicago Archives; below, courtesy of the Chicago Historical Society.)

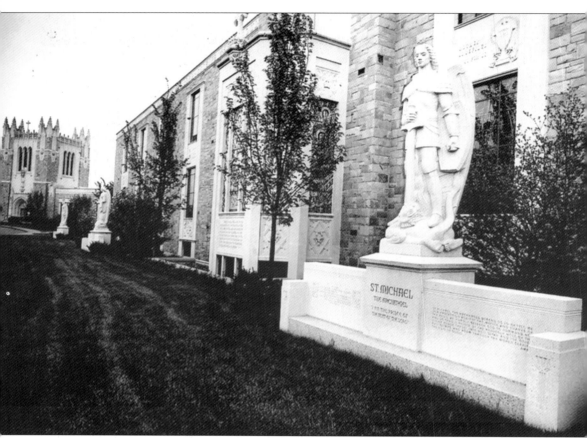

The grounds of the mausoleum used to contain large statues dedicated to the saints, such as St. Michael, who is pictured here. Around 1992, the statues were moved to the Mausoleum of the Archangels, at Holy Sepulchre Cemetery in Alsip. (Courtesy of the Archdiocese of Chicago Archives.)

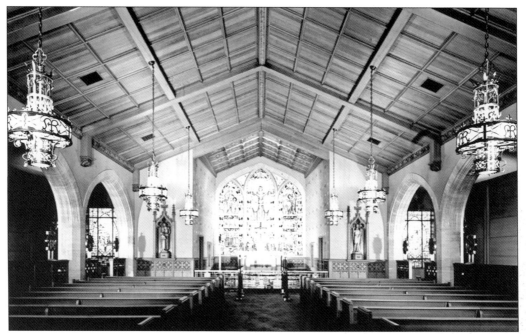

Pictured above is the Chapel of Our Lady. With arched porticos, a wooden ceiling, and the cross-shaped interior, it adheres to traditional styles of religious architecture. (Courtesy of the Chicago Historical Society.)

The Chapel of Mercy, on the other hand, with its smooth marble and sleek lines, takes on more modern overtones. The glass-enclosed case on the right contains relics of Catholic saints. Such displays are found throughout the mausoleum. (Courtesy of the Chicago Historical Society.)

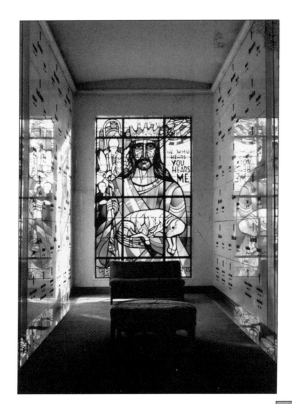

A serene atmosphere is ever present throughout the mausoleum with the intention to comfort those who mourn. Over 100 stained-glass windows depict events and people associated with Christianity.

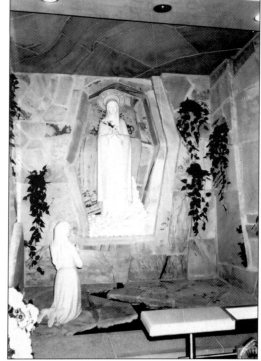

Shrine areas abound throughout the mausoleum. The Our Lady of Lourdes shrine depicts the story of the Blessed Virgin Mary, who appeared 18 times to St. Bernadette in 1858.

A multitalented artist, Italo Botti, left his indelible mark upon the mausoleum, creating stained-glass windows, sculptures, paintings, and mosaics that adorn the inside of the structure. This photograph was taken of him at his studio in New York. He is working on a full-scale drawing of one of the windows for the mausoleum. (Courtesy of Christopher Botti.)

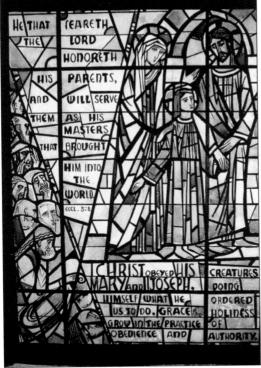

Depicting an adolescent Christ, with his parents Mary and Joseph, this beautiful stained-glass window is one of the many examples of Botti's handiwork. Many claim the mausoleum has one of the largest collections of original artwork, second only to the Art Institute of Chicago. (Courtesy of Christopher Botti.)

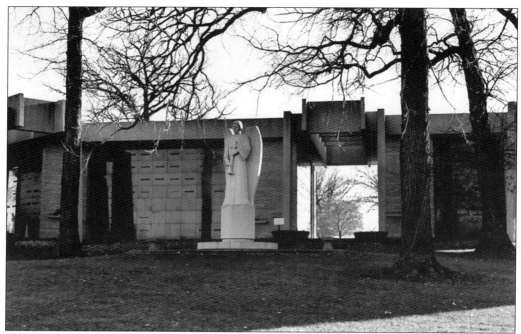

Resurrection Garden (above) was completed in 1977 and was built to hold 1,288 interments. Crucifixion Garden (below) was completed in 1981 and was built to hold 4,200 interments. The large cross has been named the Butterfly Cross. Both of these mausoleums were designed by Harley, Ellington, Pierce, Yee, and Associates of Michigan.

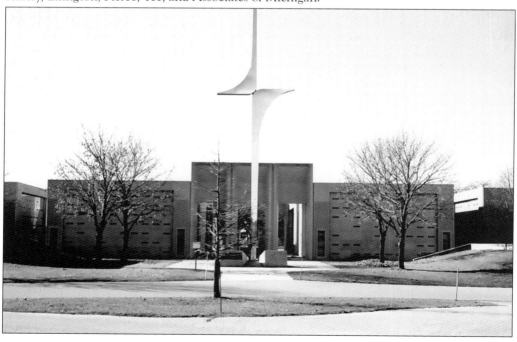

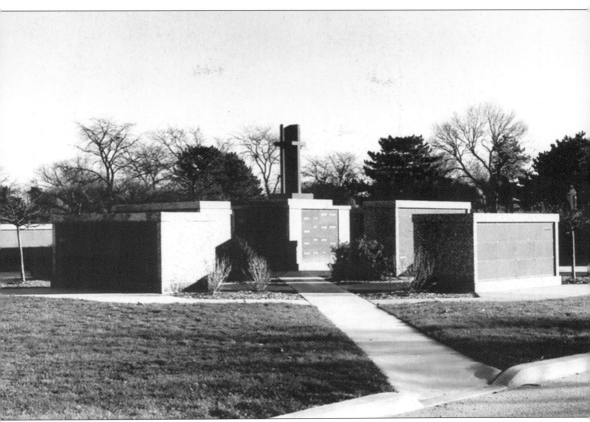

The Holy Cross Columbarium was completed in 2001 and contains 360 niches for cremated remains. Cremation used to be prohibited under the guidelines of the Catholic Church. According to Catholic Cemeteries of Chicago, "From the earliest days of Christianity, cremation was seen as a pagan ritual perceived to be contrary to this and other Catholic teachings, and therefore prohibited by the Catholic Church. In 1963, the Catholic Church lifted its prohibition forbidding Catholics to choose cremation. Canon 1176 of the 1983 Code of Canon Law states, 'The Church earnestly recommends the pious custom of burying the bodies of the dead be observed, it does not however, forbid cremation unless it has been chosen for reasons which are contrary to Christian teaching.' The Church also holds that these remains be treated with the same respect that the body was treated with prior to cremation, including the use of a worthy vessel or urn for the cremated remains of the body."

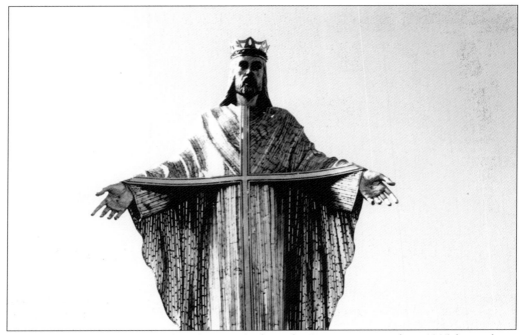

The 21-foot-tall, stainless steel sculpture of *Christ the King* was created in 1985 by sculptor Charles Parks of Wilmington, Delaware. He is known for many works including *Our Lady of the New Millennium*. Christ the King Mausoleum was completed in 1987 with the intent of holding 20,000 crypts. Due to minor changes in design, that total has now increased to 20,200. It too was designed by Harley, Ellington, Pierce, Yee, and Associates of Michigan.

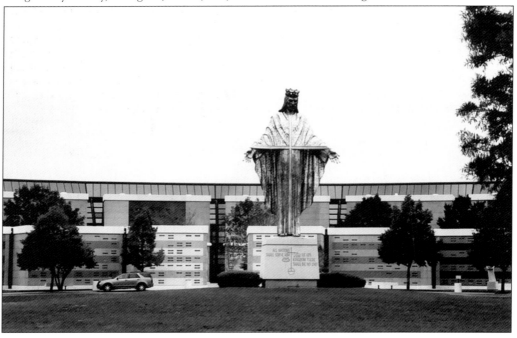

Four

GANGSTERS IN GRANITE

January 17, 1920, was a date born out of the best of intentions. The aim of the Volstead Act was to create a better society. However, as a result of Prohibition, one of the most terrifying chapters of American history was to unfold. With its proximity to Canada, no other city suffered more than Chicago. Bootlegging made many millionaires. Big Jim Colosimo, who was in control of over 200 brothels and many other criminal activities such as gambling and extortion, was murdered to make way for the Chicago Outfit, headed by Joe Torrio and then Al "Scarface" Capone. The North Side Gang led by Dean O'Banion and his associates Vincent Drucci and Hymie Weiss tried to square off with them on the streets, but like the Genna brothers, were gunned down one by one until only Scarface reigned supreme. The "handshake murder," the "drive-by shooting," the "suitcase bomb," all of these were invented in Chicago. Things became so bad that in 1933 the mayor of Chicago, Anton Cermak, was murdered. Even with a repeal of the Volstead Act in 1933, the foundation had been set for a new generation. The more infamous of these men are now laid to rest, in marble tombs and mausoleums that rival those who put them there. As a testament to their ill-gotten wealth they repose in silver and bronze caskets, with funeral processions that would have eclipsed some of the bishops'. Yet, in the ultimate irony, they are eternally interred all within the same few square feet of ground.

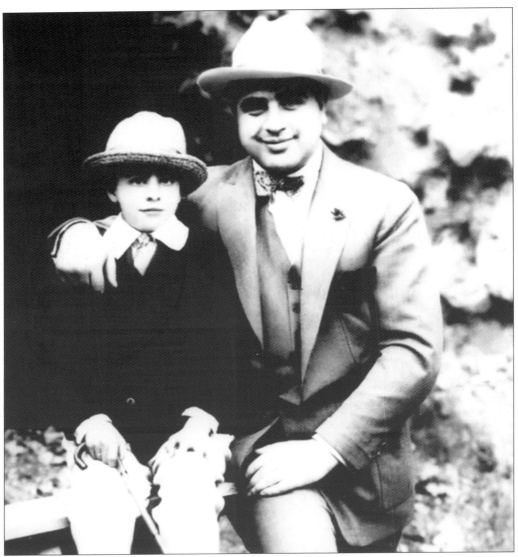

Alphonse "Big Al" Capone is indisputably Chicago's most famous citizen. Born on January 17, 1899, he came from humble beginnings to rise as one of the most notorious gangland figures ever produced in the United States. His father, Gabriel, was an immigrant from a Naples slum who settled in New York City's working-class neighborhoods. Al Capone first hooked up with Johnny Torrio there and then followed him to Chicago as he took over the city's crime syndicate following the murder of James "Big Jim" Colosimo. With the passage of the 36th Amendment, Capone and Torrio were poised to create a veritable empire in bootleg sales and speakeasies. When Capone, dubbed "Scarface" by the Chicago Press, took over the gang through muscle or murder, he ruthlessly worked to eliminate his competition. It was Capone who introduced the terrorist bomb and the drive-by shooting into the arsenal of crime. Yet oddly enough, many people worshipped him as a folk hero. With the grisly St. Valentine's Day massacre, the public's tolerance had reached a boiling point. In 1931, he was finally silenced, imprisoned for failure to pay his taxes. However, he met an early end due to complications from syphilis, a disease he contracted while still a young man, on January 25, 1947. (Courtesy of Neal Trickle.)

Burying Al Capone would be a whole other matter. He was moved from Mount Olivet Cemetery to Mount Carmel, where the Capone family burial plot now resides. Unfortunately, more conflict followed as hordes of visitors who came to pay their respects trampled other monuments in the vicinity. In order to keep the peace, the family tried to obscure his resting place with a tall hedge. Still, people found him. To this day, devotees of the fallen gangster still leave tributes in the form of cigars, cash, and religious medals by his stone. (Courtesy of Mario Gomes.)

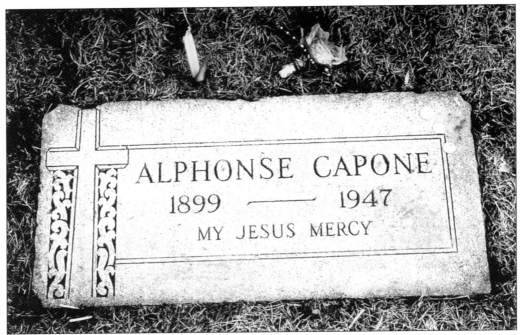

Resting in the front of the hedges is Capone's 125-pound grave marker. It has been stolen and replaced at least twice.

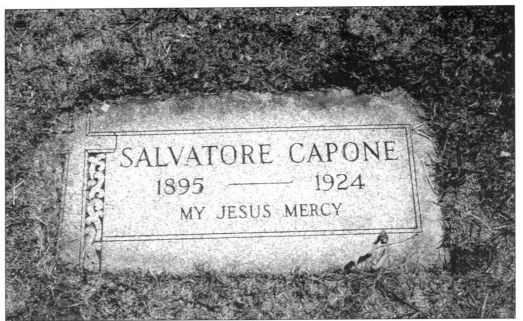

When the Torrio gang moved into Cicero in 1922, Salvatore "Frank" Capone, four years Al's senior, served as the Chicago Outfit's front man. While trying to fix an election for "Outfit-friendly" politicians, Frank was shot dead by police on April 1, 1924. His funeral was the grandest of all the Capone brothers. He was laid to rest in a silver-plated casket with $20,000 worth of flowers.

The youngest of the Capone brothers, Amedeo "Mattie" Capone was said to resent his brother Al's prominence in the Chicago syndicate. Obviously, they were not always on the best of terms. Out of Al's inner circle, he made a friend of Mickey Cohen in his youth, a Chicago hood who would become a major player in the West Coast rackets. Mattie had a brush with the law over an employee who turned up dead near the Cicero tavern that he managed. However, he laid low for a year and all charges were dropped. When he died on January 31, 1967, at the age of 59, only 25 people came to his funeral. The turnout was so low that two of the reporters who were there to cover the story were pressed into service as pallbearers. (Courtesy of the Chicago Crime Commission, created 1940.)

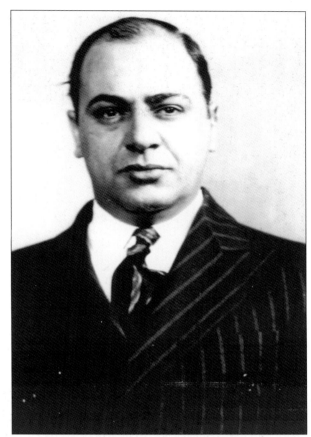

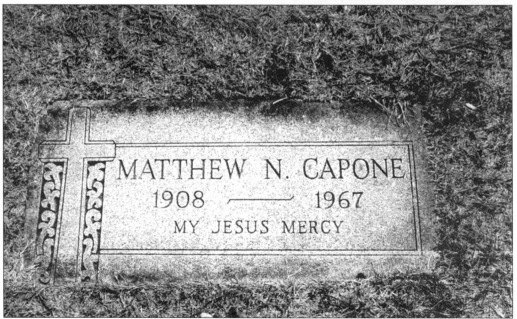

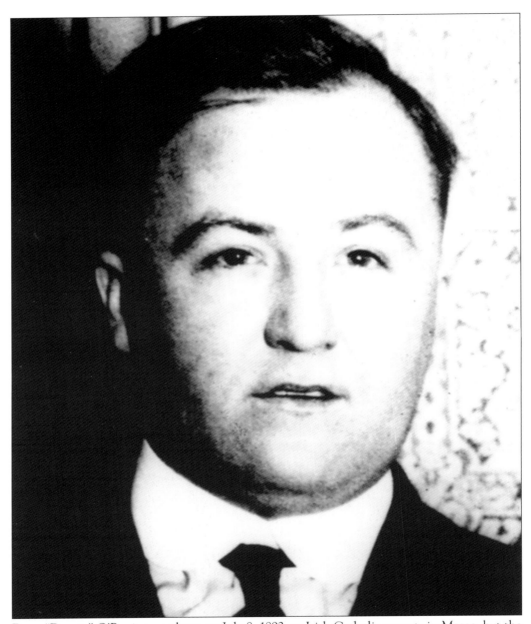

Dean "Deanie" O'Banion was born on July 8, 1892, to Irish Catholic parents in Maroa, but the family's relocation to the then dubbed "Little Hell" section of Chicago seemed to seal the fate of the christened Dean Charles O'Banion. Street life quickly seduced him as he became known for safecracking and petty crime while entertaining the pub crowd with his clear tenor voice. With the passage of prohibition, O'Banion and his friends, Vincent Drucci, Hymie Weiss, and George Moran, were uniquely poised to reap the benefits of the then illegal bootleg trade in liquor. He had the foresight to set up a Canadian distribution system and several breweries in anticipation of the act becoming law. He and his North Side gang were major players, profiting millions a year off the trade. Competition with the Torrio/Capone gang led to his elimination on November 10, 1924. (Courtesy of the estate of Dean O'Banion and Rose Keefe.)

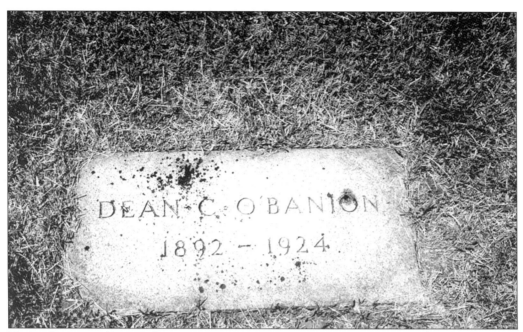

Under the guise of buying flowers for the funeral of Mike Merlo, three of Torrio's men entered O'Banion's flower shop. As O'Banion extended an arm in greeting, one of the men grasped his arm with one hand, shooting him point blank with the other. The shooting became known as the "handshake murder," becoming a staple of gangland killings. He was buried in a $10,000 casket that had to be shipped in a special car from Philadelphia. Tens of thousands of mourners tearfully came to pay tribute to the beloved gangster. It took 25 cars just to carry the flowers. The attendance at his funeral even eclipsed that of some of the bishops and cardinals. Ironically, his final resting place is located 100 feet from the Bishop's Chapel at Mount Carmel. O'Banion's remaining associates tried unsuccessfully to take out Capone. What followed was a five-year street war that Capone eventually won.

Making their name as extortionists and small-time hoods in Chicago's famed Little Italy, the Genna brothers, Tony "the Gentleman" Genna (July 2, 1890–July 8, 1925), Angelo "Bloody Angelo" Genna, seen in the photograph above, (February 3, 1898–May 26, 1925), and Mike "the Devil" Genna (January 18, 1895–June 13, 1925), struck gold when prohibition came. However, rivalries with Dean O'Banion's Northsiders and Johnny Torrio's Outfit would be their tragic undoing. Their attempt to expand into Northsider territory resulted in several armed clashes and ended up with the handshake assassination of Dean O'Banion in 1924. Reprisals came quickly. As newlywed Angelo set out one day in his car to make a house payment, a trio that was said to include Northsiders Weiss, Drucci, and Moran followed him. Trying to shake them, he crashed and was shot to death. Weeks after Angelo's funeral, Mike was killed in a shootout with police. In July, Tony was assassinated by one of his own men in the same fashion as O'Banion. All three were buried in the family mausoleum. Ironically, the Genna mausoleum is located near O'Banion's grave. One mourner was heard to say at Tony's funeral, "When Judgement Day comes and those graves are opened, there'll be hell to pay in this cemetery." With the Genna family's power wiped out, the remaining brothers fled Chicago. (Courtesy of Mario Gomes.)

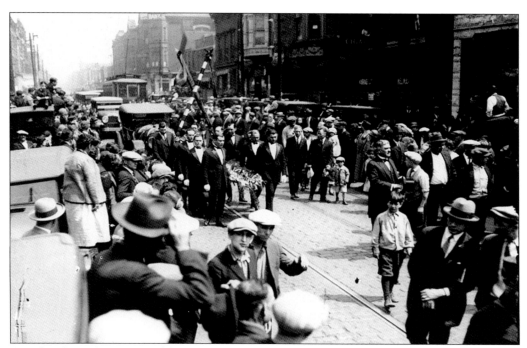

Angelo's funeral was a garishly extravagant affair, attracting hundreds of mourners. Two lines of men formed a procession down Little Italy's streets as they made their way to the burial site at Mount Carmel. A lavish amount of flowers totaling $75,000 were present at the gravesite, as evidenced in the photograph below. (Courtesy of the Chicago Historical Society.)

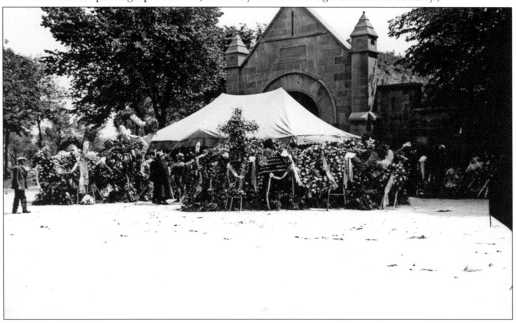

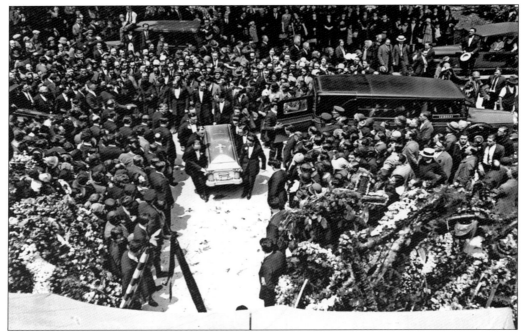

Because O'Banion's funeral had become the yardstick by which all other gangland funerals would be measured, Angelo Genna's memorial also pushed the envelope. His body was placed in a $6,000 bronze casket that weighed 1,200 pounds. He was entombed in a $10,000 vault, as bands of musicians played to a crowd of over 20,000 people. At least 25 limousines were needed to transport just the flowers. All in all, Genna's funeral was one of the most opulent gangland ceremonies noted in the history of Chicago. (Courtesy of the Chicago Historical Society.)

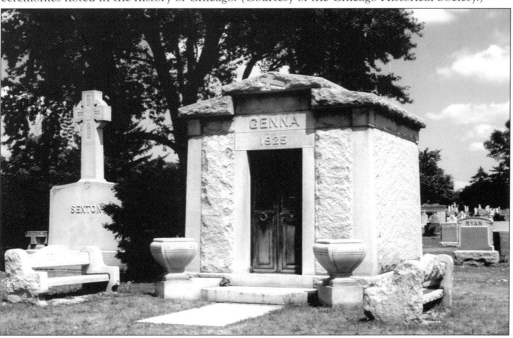

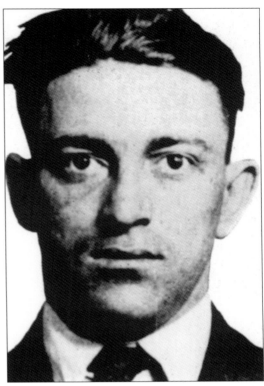

Earl "Hymie" Weiss was the only man Al Capone ever feared. Born on January 25, 1898, into an immigrant family from Poland, he was originally named Henry Earl Wojciechowski before his family changed their name to Weiss in the early 1900s. A petty criminal as a teenager, he and O'Banion formed the North Side gang that later became the rivals of the Capone gang. On January 12, 1925, and again on September 20, 1926, Weiss attempted to take out Al Capone in retaliation for O'Banion's assassination. In retribution, Weiss was gunned down on State Street in front of Holy Name Cathedral by Capone's hit men on October 28, 1926. His mausoluem is located at Mount Carmel. He is credited with coining the phrase "one-way ride." (Courtesy of Mario Gomes.)

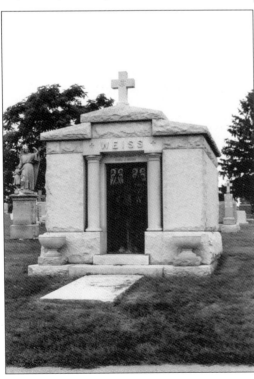

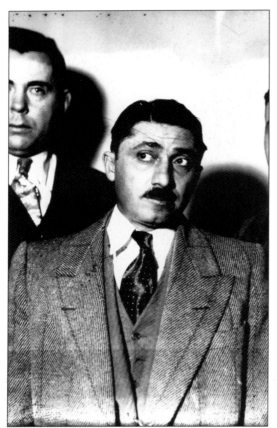

Francesco "Frank" Raffelle Nitti, seen here in 1930, came to the United States from Sicily while still a toddler. During Chicago's notorious bootleg wars between Torrio and O'Banion, Nitti was summoned to become a gunman for the Outfit. Earning the nickname "the Enforcer" he made sure that the city's speakeasies only stocked hooch supplied by the Outfit. With Capone in prison, the press assumed that Nitti was now in charge, and to keep the heat off themselves, the real heavies, Ricca and Accardo, let them believe it, often countermanding his decisions behind his back. As a member of the "Commission," or so-called Mafiosi board of directors, it was Ricca who had the real power. However, this power struggle would come to an end when many of Chicago's gangsters, Ricca and Nitti included, were indicted on federal charges in the Hollywood Union scandal. Rather than face trial and perhaps prison time, on March 19, 1943, Frank Nitti walked to a railroad, put a pistol to his head, and pulled the trigger. This made the 55- or 56-year-old Nitti the only known mob boss to commit suicide. His grave is located near "Big Al." (Courtesy of the Chicago Historical Society.)

Perhaps one of the most colorful gangsters of the bootleg era, Vincent "the Schemer" Drucci was born Ludovico D'Ambrosio on April 28, 1899, to an immigrant family. After nobly serving his country in the U.S. Navy, he turned to a life of crime. He earned his reputation as a strong-arm robbery man, masterminding schemes that netted thousands, thus earning his nickname, the Schemer. As an associate of Dean O'Banion, he played a pivotal role in the Weiss-Capone turf wars of the 1920s. He died on April 4, 1927, and he is the only gangster to have the distinction of having a flag-draped casket and a 21-gun salute. His casket was made of silver and aluminum at a cost of $10,000 and was surrounded by $30,000 worth of floral arrangements. Over 1,000 people attended his funeral at Mount Carmel. (Courtesy of Mario Gomes.)

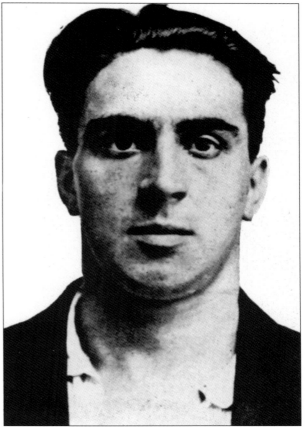

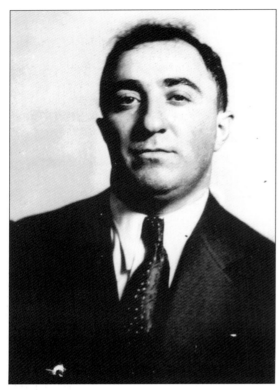

Born in Brooklyn in 1900, Louis Campagna was rumored to have been a member of New York's Five Points Gang with Al Capone. Louis, aka "Little New York," made his way west to Illinois while still a teenager. A botched robbery sent him to prison until he was 24. When he emerged in the mid-1920s, he hooked up with Capone, becoming one of his bodyguards. With Capone in jail, Campagna, seen here in 1932, rose in the ranks, sharing in gambling profits with Heeney and skimming the treasuries of local labor unions. Indestructible in the face of rivals and the Kefauver Committee, Campagna was taken down by a 30-pound grouper. He died of a heart attack while on a fishing trip in Florida on May 30, 1955. (Courtesy of the Chicago Crime Commission.)

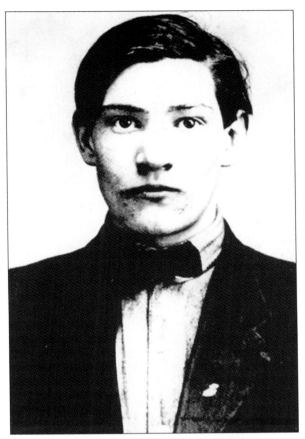

More famous in death than he was in life, John May was an ex-safecracker who was trying to earn a living as an automobile mechanic for $50 a week. It was his job to keep the fleet that ran the Moran gang's bootleg liquor in working order. It would be his fatal misfortune to be present in the Chicago garage on the morning of February 14, 1929, when Capone's hit men tried to take out Moran and killed seven men in what came to be known as the St. Valentine's Day Massacre. He was the sole supporter of an ailing wife and seven stepchildren. A gun shot took off half his face. The 34 year old was buried at Mount Carmel with his wife, but no headstone marks his grave. (Courtesy of the Goddard Collection.)

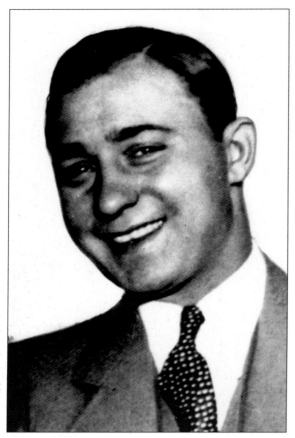

Born James Vincenzo Gibaldi on July 2, 1903, in Licata, Sicily, he arrived at Ellis Island in 1906 at the age of one. Destined to be a mafia hit man, he changed his name as an aspiring boxer while still in his teens to "Battling" Jack McGurn. He is seen here in 1931. His life took a tragic turn toward crime in the 1920s when his father was murdered and he took a vow of vengeance. Now known as "Machine Gun" Jack McGurn, under Capone he was directly responsible for dozens of murders and even a suspect in the St. Valentine's Day Massacre. Ironically, he too was apparently the victim of a vendetta, found gunned down in a bowling alley on February 15, 1936. An incorrect date is shown on his stone along with another assumed name. He is buried among family members at Mount Carmel. (Courtesy of the Chicago Historical Society.)

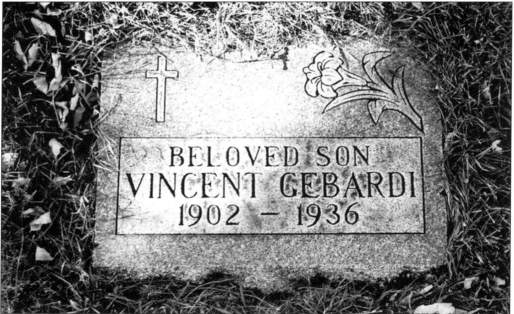

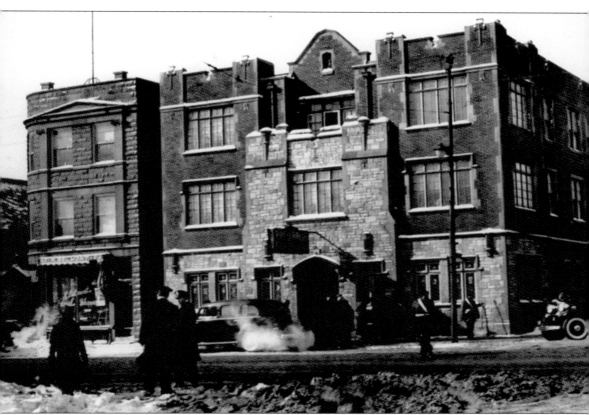

Jack McGurn's wake, pictured here, was held at Rago Brothers Funeral Home at 624 North Western Avenue. Even though he was an inmate at Alcatraz, Capone still managed to send a six-foot-high display of roses. McGurn's casket was valued at just under $1,000. Only 27 cars made the trip to Hillside. Most of the attendees were family members. Unlike most Chicago gangsters, McGurn's funeral service was devoid of the traditional pomp and splendor. (Courtesy of the Chicago Historical Society.)

A known friend of Anthony D'Andrea, by all appearances Joe Laspisa was not someone that most of his family and friends thought had any connections to Chicago organized crime. He was a man of charitable good works as the president of Ventimiglia, an Italian mutual benefit society. He was on an errand for the association when he was gunned down on June 27, 1921. His beautifully carved monument rests at Mount Carmel. At his death his lawyer announced that his killing must have been a mistake, yet there were rumors of his involvement in a 1913 shooting and worry that he might squeal what he knew about D'Andrea's murder.

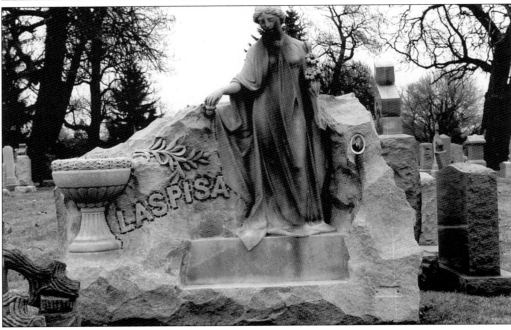

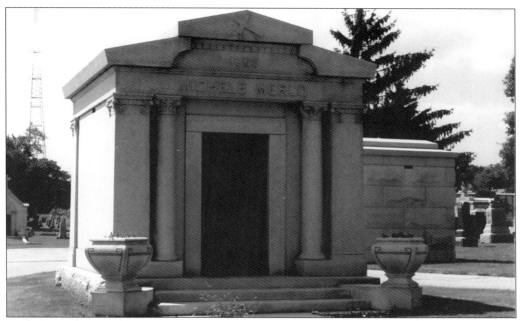

Michele "Mike" Merlo was one of the most respected presidents of the Unione Siciliana, an organization that was a front for organized crime. After his November 9, 1924, death, there were over $100,000 worth of flowers at his service. The most striking of which was a 12-foot statue of Merlo made out of blossoms. His mausoleum is located at Mount Carmel.

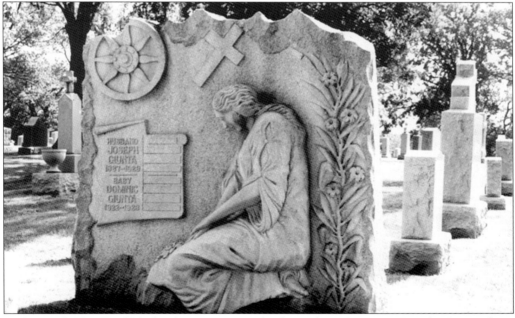

Nicknamed "Hop Toad" for his fancy moves on the dance floor, Giuseppe "Joseph" Giunta, born in 1887, was a high-ranking member of the Capone gang. In 1929, along with Scalise and Anselmi, he tried to make a grab at power by plotting the assassination of Capone. In a now infamous incident, Capone invited the trio to a dinner party where they were bludgeoned to death.

Former Public Enemy No. 7, William "Willie" Heeney, seen here in 1907, originally hailed from St. Louis' notorious Kerry Patch District. A descendant of Irish immigrants, Heeney was born on February 13, 1887. He was a top hit man for Al Capone, serving as his "chief of staff" in Cicero. The FBI suspects that he was one of the triggermen who murdered Jack McGurn, who was believed to be one of the St. Valentine's Day gunmen. Succeeding Capone as one of Chicago's top gambling bosses, he was an associate of Paul Ricca, Louis Campagna, and Philip D'Andrea. While he was investigated on federal charges that convicted his contemporaries, he was never charged, thus earning the moniker the "sneaky Irishmen." He died of throat cancer at the age of 61 on July 13, 1951, and was buried at Mount Carmel. (Courtesy of the Chicago Crime Commission.)

WILLIAM E. HEENEY
FEB. 13, 1887
JULY 13, 1951

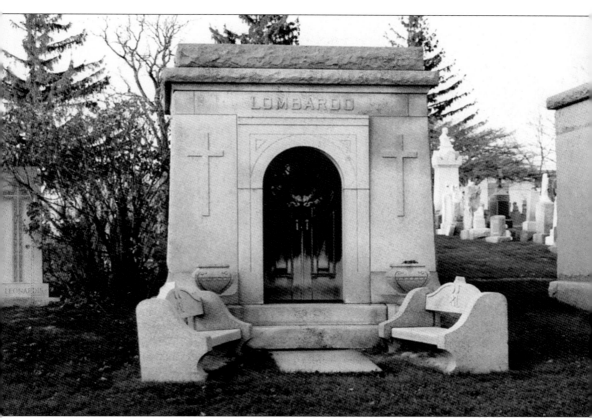

Anthonio "Tony" Lombardo came to this country with only $12 in his pocket. He would become a friend to Al Capone and the well-respected president of the Unione Siciliana. But Lombardo had made enemies of many rival gangsters. Among the Chicago syndicate, it had long been suspected that he had been involved in the murder of Frankie Yale. In retaliation, it was rumored that it was associates of Aiello who took him down in a most spectacular fashion. He was near the busiest intersection in Chicago at the time, State and Madison Streets, when he was gunned down in front of thousands of witnesses during the evening rush hour on September 7, 1928. With 17 carloads of flowers and a funeral cortege two miles long, his burial in Mount Carmel was one of the most spectacular of the era. Capone personally attended his funeral.

Paul Ricca, born in 1897, was nicknamed "the Waiter" because his entree to organized crime came as an employee to restaurateur Joe Esposito. Ricca, who is pictured here on June 6, 1948, rose to the top rank of the Outfit. He was indicted on federal charges, and after serving 10 years, he was forced to pass the reins to Tony Accardo. Ricca died on October 11, 1972, and is interred in Queen of Heaven Cemetery. (Courtesy of the Chicago Crime Commission.)

Born on December 1, 1907, Joseph Aiuppa joined the Outfit in 1935. By the 1970s, he had risen through the ranks, controlling mob operations in Cicero. He became mob boss Tony Accardo's top enforcer. In 1985, he was convicted in the Las Vegas Casino scandal and sentenced to 28 years. He died in prison on February 22, 1997. He is interred in Queen of Heaven Cemetery. (Courtesy of the Chicago Crime Commission.)

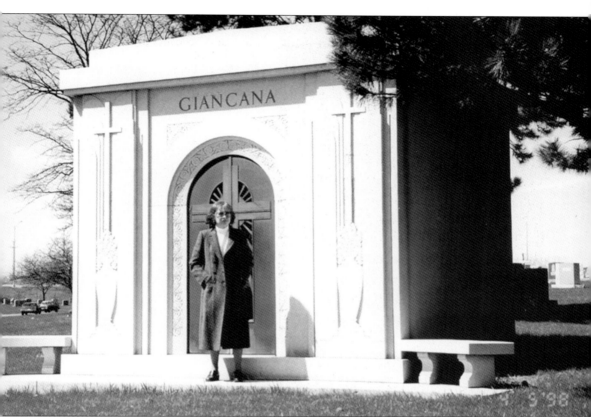

With links to Frank Sinatra, Judy Garland, the McGuire Sisters, and a failed plot to kill Fidel Castro, Sam "Mooney" Giancana, born on June 15, 1908, was one of the more high-profile gangsters of recent times. With heavy ties to alleged Las Vegas gaming payoffs, Giancana spent a good deal of his reign ducking federal racketeering charges. After returning from a self-imposed exile in Mexico, leader of the Outfit Giancana was murdered in his kitchen while cooking sausages on June 19, 1975. Facing a federal prison term, his mob associates were afraid he might start talking. His daughter, Antoinette, memorialized him in a 1984 memoir entitled *Mafia Princess*. So popular was this man's persona that his grave is still an attraction. Barbara Merkowska, an immigrant from Poland in 1964, sought out his mausoleum at Mount Carmel in 1998 to pose for the above photograph. (Courtesy of Richard Merkowski.)

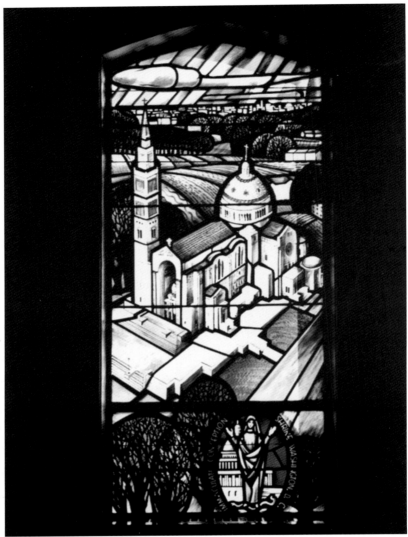

A home-grown product of Chicago's mean streets born on April 28, 1906, Anthony "Joe Batters" Accardo rose through the ranks of the city's crime syndicates during the prohibition era. A member of the Outfit, he served as Al Capone's bodyguard and as a soldier under Frank Nitti and Paul Ricca before taking over the reins as boss. The newspapers dubbed him "Big Tuna," but it was Capone himself who nicknamed him "Joe Batters." Ruling from 1943 to 1957, he expanded the Outfit's influence into most of the western states, including the city of Las Vegas. He brutally enforced the syndicate's ban on drug dealing in an administration notable for bloodshed and murder. He was succeeded by under-boss Sam Giancana. By the time of his death, May 27, 1992, federal investigations into casino skimming operations had decimated the power of the Chicago mob. His funeral service bore this out. Mostly family members comprised the five-car cortege that took his simple wooden casket to Queen of Heaven for burial. Two former cronies, Joseph Amato and Rocco DeGrazio, were seen briefly in attendance, yet the most notable of his pallbearers was his son Eric, a member of the Chicago Bears. Only two sprays of roses adorned his casket. The day of the grand gangster funeral had, indeed, slipped into history. This stained-glass window is located in Accardo's private alcove inside the main mausoleum.

Five

A Century of Tragedy

A beautiful spring morning with the anticipation of a leisurely cruise. Front row seats to a performance featuring Eddie Foy. Waiting for the dismissal bell on a late fall day with Christmas only a few weeks away. These outings all started innocently enough, but were moments away from terror, and tragedy. From the Iroquois Theatre fire, to the Eastland disaster, to the Our Lady of the Angels School fire, Mount Carmel and Queen of Heaven have served as a place to gather and mourn the loss of life and to permanently memorialize those whose time on earth was tragically cut short. At Queen of Heaven there is a permanent memorial to the 89 children who died in the Our Lady of the Angels school fire, listing the names of all the victims, many of whom are interred together in the Holy Innocents section. Burials reached an all-time high of 87 in one day in October during the 1918 flu epidemic, the victims of which are scattered throughout Mount Carmel. The result of these tragedies had national implications; more people died during the 1918 epidemic than had died in World War I. Yet the result was to be the development of vaccines and greater public health awareness. Both the Iroquois Theatre fire and the Our Lady of the Angels school fire resulted in a national institution of fire safety standards for public buildings and schools. Yet the stark effect of these countless names etched in granite serves as a reminder of the vigilant need to preserve standards for public safety.

On December 30, 1903, a spotlight exploded, igniting the stage of the newly built Iroquois Theatre. Fireman Peter Mutter was dispatched from Company No. 12. Cited for gallant conduct, he had to struggle with locked gates and inaccessible alleyways to get inside. In minutes, 602 theatergoers lay dead—burned, asphyxiated, or trampled. Most of the victims were women and children. Mutter never recovered from the horror he witnessed that day, dying two years later of unrelated causes. His headstone, in the shape of a tree, was an emblematic symbol for firemen and policemen of the era.

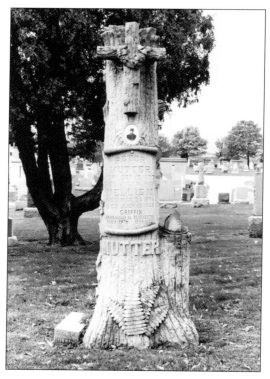

On December 22, 1910, the initial call came in at 4:42 a.m. A major structure at the Union Stockyard, the slaughterhouse made famous in Upton Sinclair's *The Jungle*, was engulfed in flames. Peter Powers, along with fellow firefighters of Hook and Ladder Company 11 rushed to the scene. This particular fire started in a freezer warehouse that had no sprinkler system and was blocked by railcars. As Powers and the men of his company attempted to hack down the freight doors and gain access to the building, a back draft occurred inside, causing an explosion. When frantic firemen were able to clear the rubble almost two days later, Powers's body, along with that of every member of Ladder 11 was recovered. The Stockyard Fire of 1910, as it became known, took the lives of 24 firemen and three railway workers. For the Chicago Fire Department, it remains the greatest one-day loss of life to their ranks.

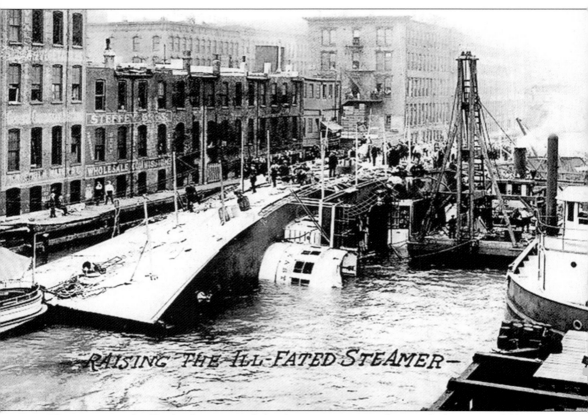

RAISING THE ILL-FATED STEAMER—

The outing on the *Eastland* was intended to be an expression of gratitude from one of Chicago's major companies to its employees. It turned out to be one of the greatest tragedies in Chicago's history. On the morning of July 24, 1915, over 2,000 employees of the Western Electric Company boarded the *Eastland*, a ship docked on the Chicago River that was headed for a picnic outing across Lake Michigan. What the passengers did not know that ill-fated morning was that the steamer nicknamed "the aristocrat of the lakes" had always had a problem with stability. Simply put, the vessel was top heavy, and recent improvements to stabilize the ship only made it worse. Ironically, in the wake of the Titanic disaster, the fatal move proved to be adding more lifeboats. As passengers boarded, loading the ship to its capacity, lines holding the *Eastland* to the pier snapped and the boat rolled over. (Courtesy of Karl Sup and the Eastland Memorial Society.)

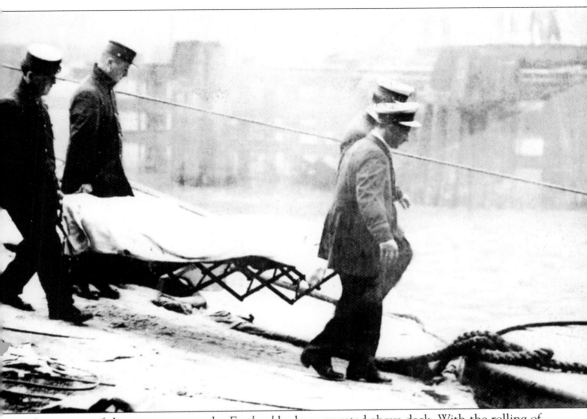

A majority of the passengers on the *Eastland* had congregated above deck. With the rolling of the ship, they slipped into the water. The water become thick with people stacked above and below the surface. Those underwater pulled down those above, creating a situation that was impossible for escape. Nearby boats and good samaritans began rescue operations immediately. However, flotation devices thrown at the struggling victims sometimes exacerbated the situation by further clogging the water. Screams came from inside the hull as onlookers tried desperately to use blowtorches to cut holes to allow trapped passengers to escape. By 8:00 a.m., all potential survivors had been rescued. Choked with victims, rescuers had to use nets to retrieve the bodies. Recovery lasted for three days as divers carefully searched for remains within the hold of the ship. When it was over, the death toll stood at a staggering 844. (Courtesy of Karl Sup and the Eastland Memorial Society.)

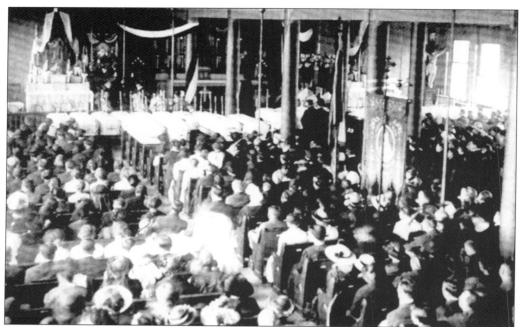

The scale of the *Eastland* tragedy was difficult to grasp. At the above funeral mass, the coffins were so numerous that they had to rest on the front row of pews. Hearses became a scarce commodity as witnessed below. Retailer Marshall Field felt compelled to donate delivery trucks in order to aid those grieving families struggling to provide a proper funeral. (Courtesy of Karl Sup and the Eastland Memorial Society.)

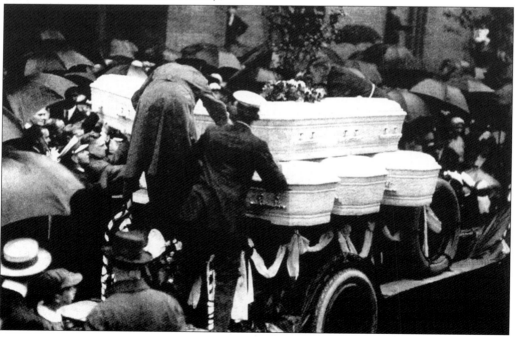

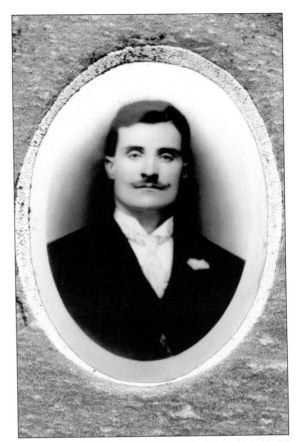

A machine hand for Western Electric, 36-year-old Leonardo Greco perished in the water, as did 17-year-old Florence Drury. Both are buried in adjacent sections in Mount Carmel Cemetery. Although the majority of the victims were of German descent, death cut deeply across many of Chicago's cultural and ethnic enclaves.

Entire families were wiped out in the disaster, as evidenced by the Clark family, buried at Mount Carmel. William Clark, 20, was an employee of Western Electric who died with his 19-year-old wife, Alice B., and their 9-month-old infant, Alice.

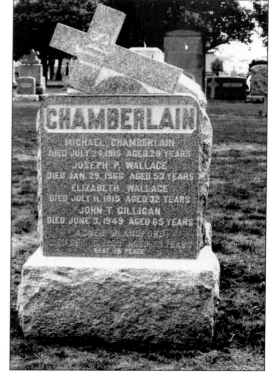

Crew members made up almost half of the dead in the *Titanic* disaster, while more passengers perished on the *Eastland*. One of them was Michael Gallager Chamberlain, a married 28-year-old elevator operator for Western Electric. All totaled, Mount Carmel interred approximately 70 people from this disaster.

PREVENT DISEASE

CARELESS
SPITTING, COUGHING, SNEEZING,
SPREAD INFLUENZA
and TUBERCULOSIS

Believed to have originated from livestock to humans in Spain, the Spanish flu first made its appearance in the United States in July 1918. By that time, it had ravaged population centers in Europe. In the United States, it was first reported in port towns like New York and Boston. The first appearance of the flu in Chicago was traced to the Great Lakes Naval Station and Camp Grant, north of the city along the shores of Lake Michigan.

INFLUENZA
KEEP OUT

NOTICE: No person shall be permitted to enter or leave these premises except as provided by the Rules and Regulations of the State Board of Health.

Signed_____
MAYOR or TOWNSHIP CLERK

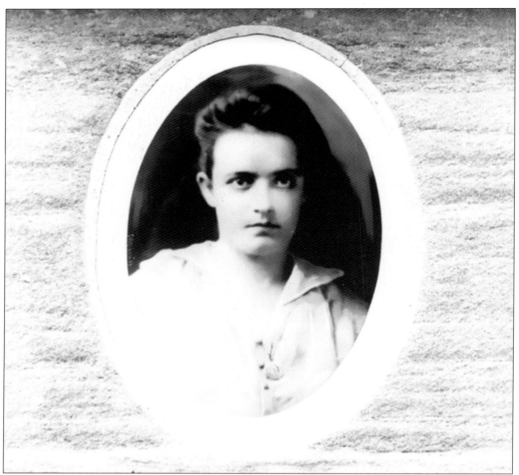

Due to close living quarters, the disease spread rapidly, first through military ranks. then to North Shore communities, and finally into the city. Unlike previous epidemics, this one seemed to strike those in the prime of life. Gemma Sipari was one such victim. A 26-year-old wife and mother, the immigrant from Abruzzo, Italy, felt hopeful, as she had successfully nursed her husband and children through the disease. Yet, she too, tragically fell ill and succumbed quickly, leaving behind five children, all under the age of 10. All over Chicago, public places closed to limit the spread of the disease. Anyone caught spitting was arrested. By the end of the eight-week period, more than 8,500 people had died in Chicago. Funeral homes and workers at Mount Carmel found it difficult to meet the demand for their services. During one day in October, Mount Carmel reportedly staged 87 funerals, a record that hopefully will never be broken.

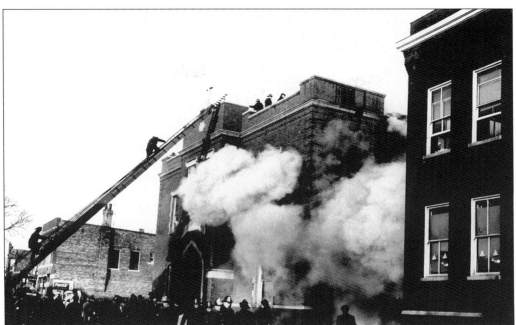

December 1, 1958, became known as "the day Chicago wept." Located at 3808 Iowa Street, Our Lady of the Angels, built in 1910 as a church and later converted to a school, did not possess any of the safety measures that would have minimized damage in case of a fire. There were no sprinkler systems, smoke detectors, automatic fire alarms, or fire safety doors. The only safety feature was one lone fire escape. Tragically the door leading down to it was locked on this fateful day. Between 2:00 p.m. and 2:20 p.m., a fire started in a stairwell below the second floor of the building's north wing. The fire began unnoticed, and then, using the building's wooden beam structure for fuel, it quickly traveled up to the second floor where six classrooms were located. (Courtesy of the Chicago Historical Society.)

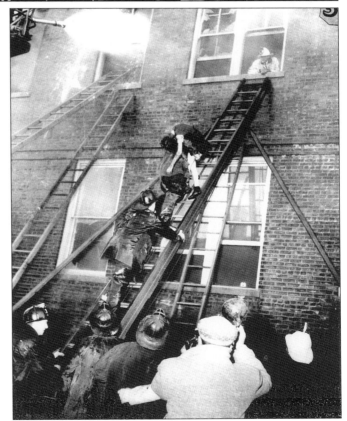

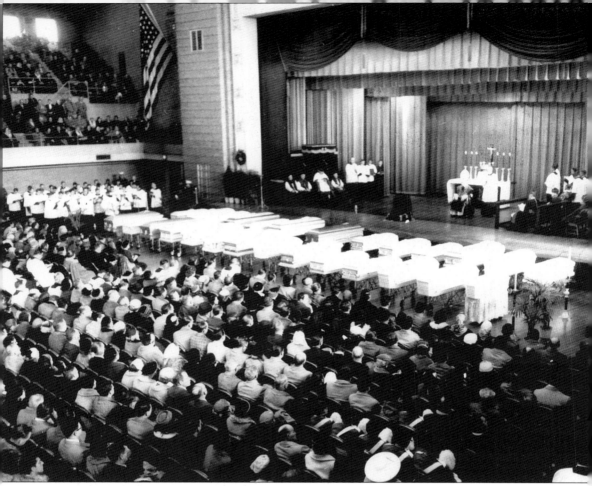

It was the nation's third worst school fire, and it took the lives of 92 students and three nuns. Four days after the tragedy, a solemn mass was held at the National Guard Armory for many of the victims. Twenty-eight small coffins lay in the austere setting, reflecting the magnitude of the tragedy. The service was a private one, only for family members of the victims, and was officiated by Archbishop Albert Gregory Meyer. An estimated 7,000 mourners were in attendance to witness the deliverance of last rites. Cardinal Francis Spellman of New York was also in observance. (Courtesy of the Chicago Historical Society.)

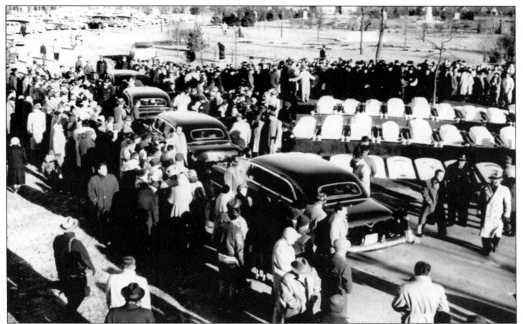

Following the funeral service, a crowd of thousands gathered at Queen of Heaven where, in the Holy Innocents section, many of the victims were buried. The others were buried in family plots in private services. The Most Reverend Albert Gregory Meyer, archbishop of Chicago, presided over the mass for the children and is pictured praying at their grave sites here with Archbishop Francis J. McElligott, archdiocesan director of cemeteries. (Courtesy of the Catholic New World.)

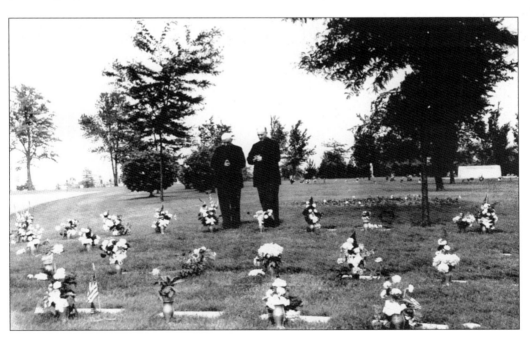

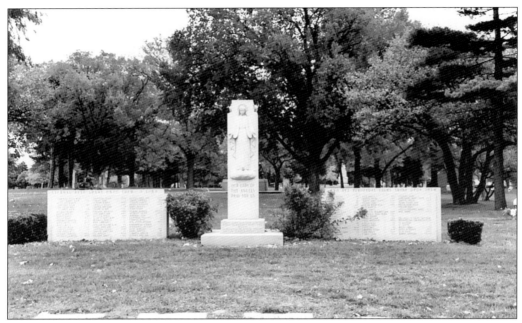

A statue of the Virgin Mary was erected at Queen of Heaven to watch over the graves of the children buried there. She is flanked by monuments engraved with the names of all of the victims of the Our Lady of the Angels fire. All totaled, Queen of Heaven interred 45 children, while Mount Carmel laid 11 children and three nuns to rest.

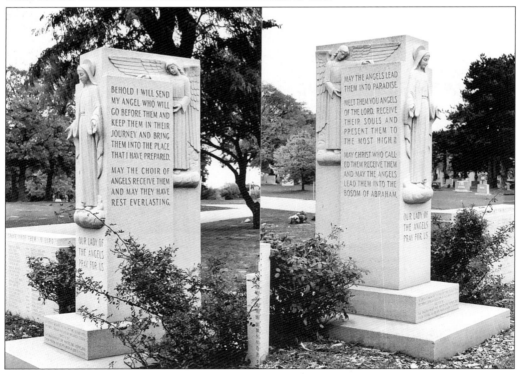

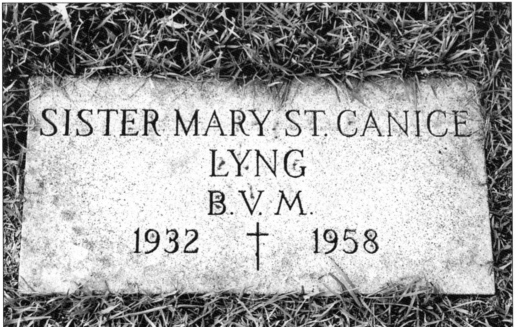

Forty-four-year-old Sr. Mary St. Canice was teaching a lesson to her seventh graders when the fire broke out underneath her classroom, 208. Once smoke oozed into the classroom, she urged her students to go to the windows. She managed to save half her students, first by calming them, and then by passing them to firefighters once they came to the scene. She was last seen going inside to retrieve a student when the roof collapsed. (Courtesy of the Mount Carmel Sisters of Charity, Dubuque, Iowa.)

SISTER MARY ST. CANICE
LYNG
B.V.M.
1932 † 1958

Forty-three-year-old Sr. Mary Seraphica Kelley's classroom, 210, was also located on the west side of the north wing next to Sr. Mary St. Canice. She had charge of the youngest victims of the fire, the fourth-grade class. More students died in her classroom than any other. Apparently she tried to calm her young charges by leading them in prayer while waiting for rescue. There were 28 bodies of the 9 and 10 year olds found in her room, many clinging to her robes for protection. (Courtesy of the Mount Carmel Sisters of Charity, Dubuque, Iowa.)

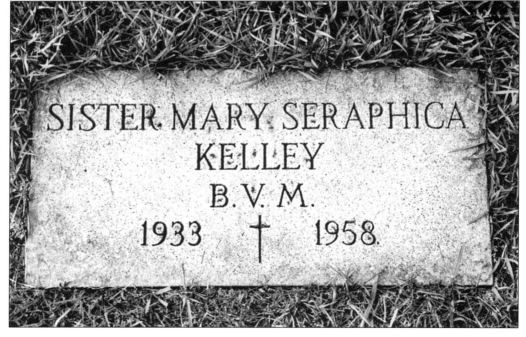

The youngest of the sisters to die in the fire was 27-year-old Sr. Mary Clare Therese Champagne, a native of New Orleans and one of the school's most beloved teachers. One of her surviving students would remark, "She was as cool as a cucumber," helping her fifth-grade students up on the window ledges and calming them as they waited for rescue. Unfortunately for her, and 26 of her charges, it came too late, as they died of asphyxiation. The engraved birth year on her headstone is obviously a mistake. (Courtesy of the Mount Carmel Sisters of Charity, Dubuque, Iowa.)

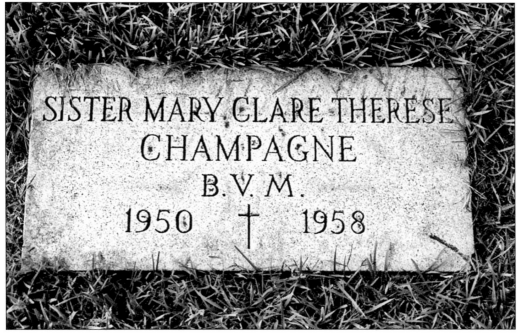

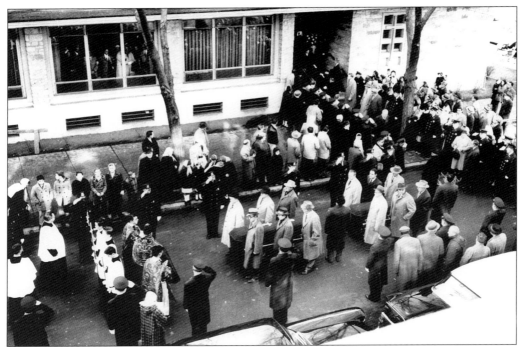

An estimated 10,000 mourners came to pay respects for the three brave B.V.M. nuns who died trying to save their students. The funeral mass was held three days after the fire at the Our Lady of the Angels parish church where mourners could still detect the smell of smoke in the air. The funerary procession to Hillside was massive. The three sisters were laid to rest together in a section dedicated to the Sisters of Charity of the Blessed Virgin Mary at Mount Carmel. (Above, courtesy of the Chicago Historical Society; below, courtesy of the Catholic New World.)

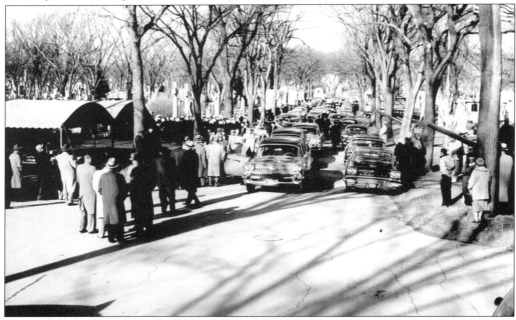

Six

CHICAGOANS

In the century since the inception of Mount Carmel and Queen of Heaven, the city of Chicago has seen immense change, and with that change has come a diverse cast of people who have worked toward shaping the city into one of America's industrial and cultural giants. The roles played by the Chicagoans who share the spotlight here are just as diverse. Some are noteworthy because of their contributions to business, government, or entertainment. Others are included because of their service to the public, their accomplishments in the world of sports, or whether in life or death they managed to capture the public eye. All of them are representative of the various waves of immigration that have affected the city over the past 100 years, and have shaped the enclaves that make up Chicago's diverse ethnic and cultural mosaic. Yet the one thing they all share is a common memorial and a common faith. They are a testament to the enduring link between Chicago's past and its future.

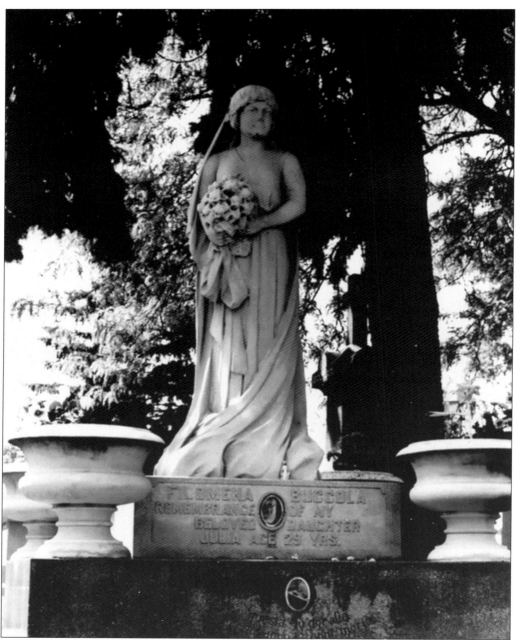

The second most famous resident at either Mount Carmel or Queen of Heaven was a 29-year-old daughter of Italian immigrants now known as "the Italian Bride." In 1921, Julia Buccola Petta died due to complications during childbirth. For Sicilians, it is customary to bury a mother who sacrifices her life for her child in her wedding dress. Her stillborn infant was placed in her arms, and the casket was lowered into a modest grave at Mount Carmel. Shortly thereafter, her mother, Philomena Buccola started to have a series of troubling dreams, where Julia was alive and begging to be exhumed. This put in motion a six-year odyssey on Philomena's part to have the casket opened.

Finally, in 1927, the grave was dug up. What beheld the eyes of those in attendance was nothing short of a miracle. While the baby's body had deteriorated in its mother's arms, Julia's body lay perfectly intact. In Catholicism, this "incorruptible" state is sometimes present in the remains of the saints and is considered to be evidence of a divine sign of holiness. Before reburying the body, this photograph of her uncorrupted corpse was taken and placed next to another from her wedding day. It is the wedding photograph that was used to fashion the monument that stands there today. Many women who wish to conceive a child and others who are with child are often seen praying at her grave. With rumors of her ghost wandering throughout the grounds, she is the cemetery's most enduring mystery.

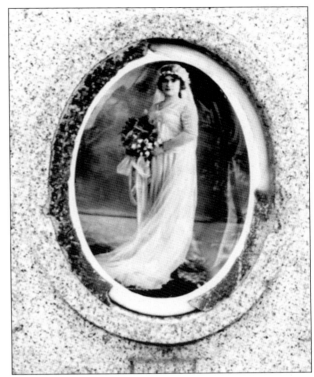

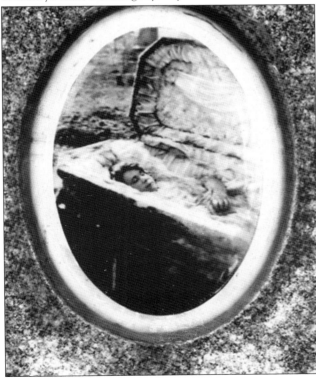

A soldier in the Union Army during the Civil War, Louis Jeanottelle Sacriste was a veteran of the bloody campaign at Chancelloersville and at Auburn, in Virginia in 1863. He received the Medal of Honor for courageous action by carrying orders that saved the picket line of the 1st Division, 2nd Army Corps, and he kept a 5th Marine Battery gun from falling into Confederate hands. Sacriste was born on June 15, 1843, and died on August 18, 1904.

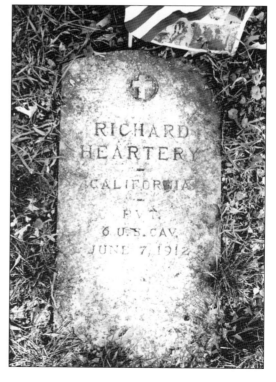

Richard Heartery (1847–June 7, 1912) was a private in Company D, 6th U.S. Calvary. He distinguished himself during the Indian Campaign in 1881, fighting Plains Indian tribes in Arizona. The Ireland-born cavalryman received the Congressional Medal of Honor for exhibiting bravery in action.

Filled with the spirit of Irish patriotism, the Clan-na-Gael was an organization that formed in the late 1890s and whose stated mission was to fight British tyranny. In 1899, the Boer War presented just such an opportunity to combat the British. Tragically, all volunteers from the Chicago chapter were killed in one battle. This monument at Mount Carmel is a tribute to their sacrifice.

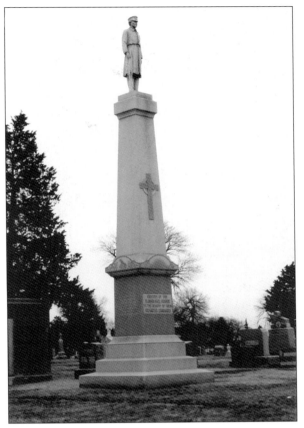

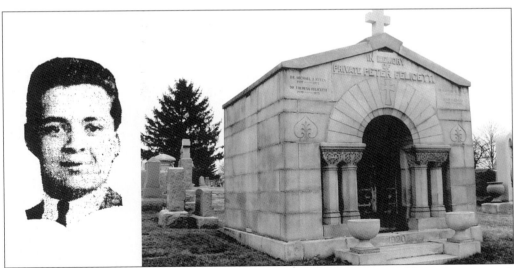

A year into World War I, Congress expanded the draft age to meet the need for more personnel. As first reports of the Spanish flu virus appeared in the summer of 1918, it could not have come at a worse time for new recruits like Peter Felicetti. His death notice indicates that he died that summer, at Camp Jackson in South Carolina.

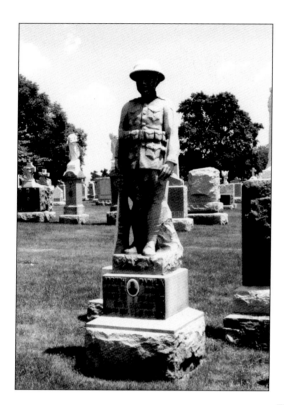

More than any other minority or ethnic group, Italian Americans made up the majority of recruits for both World War I and World War II. Sadly, they also constitute many of the more touching memorials at Mount Carmel, such as this likeness in stone of Joseph Padula, who died in France on October 25, 1918. The 31 year old also succumbed to disease.

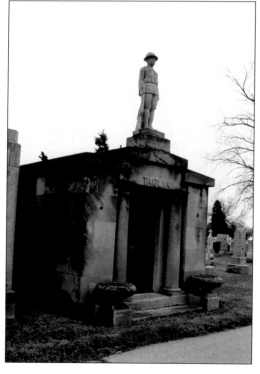

Standing guard over the family mausoleum at Mount Carmel, Onofrio Taglia also died while serving his newly adopted country during World War I. He passed away while encamped on U.S. soil, at Camp Logan near Houston, Texas. Yet, unlike Felicetti, it is more likely that Taglia died of wounds that occurred from battle, since Camp Logan was a hospital that specialized in the treatment of battlefield wounds at the time.

The American flag raised on Mount Suribachi in Iwo Jima produced one of the most famous images from World War II. After almost a month of fighting, the Marines captured a key point on the small island of Iwo Jima and spontaneously the combatants of the battle conceived of a gesture intended to inspire their fellow soldiers. James R. Michels (January 18, 1918–January 17, 1982) is pictured in the foreground, as they raised a flag over Mount Suribachi. The problem was, it was small and not visible from a distance, so the following day, they did it again, creating the famous photograph by Joe Rosenthal. The photograph below was taken of Michels at Camp Pendelton, California, around 1943. Michels is interred in Queen of Heaven Cemetery. (Courtesy of Sgt. Louis Lowery and Betty Michels McMahon.)

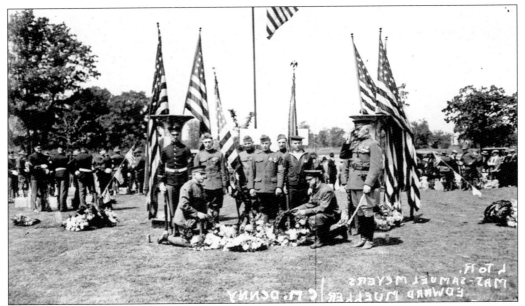

This group portrait of Maj. Samuel Meyers, Maj. Edward Mueller, Capt. B. L. Maloney, Capt. J. F. Adams, William F. Snyder, Charles Neitzel, C. M. Denny, P. Schweder, Anthony Ferrandina, F. G. Novak, and Julius Prado shows them gathered around grave sites decorated with American flags and flowers on Memorial Day at Mount Carmel Cemetery in 1922. (Courtesy of the Chicago Historical Society.)

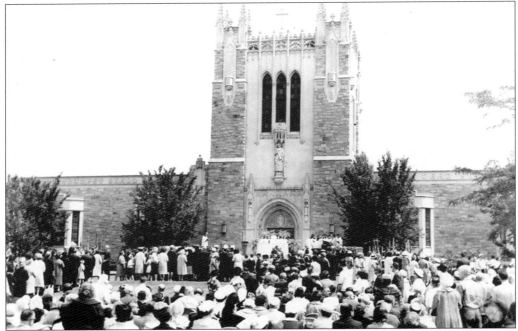

Almost 4,000 people were in attendance for the Memorial Day mass at Queen of Heaven Cemetery in 1964, which was celebrated by Albert Cardinal Meyer. (Courtesy of the Archdiocese of Chicago Archives.)

Above and below are images from Memorial Day 2005. The Italian American War Veterans (I-TAM) stage an annual processional to mark the occasion. The group is comprised of World War II, Korean, and Vietnam-era veterans. Pictured with the rifle in the foreground of the above photograph is Gino Renda, past state commander of the organization. As an army corporal, Renda served in Germany during the Korean War. Below is a picture of the I-TAM veterans, along with members of the Ladies Auxiliary. Pictured second from right is Rose Marie Renda, Gino's wife, she too is a past state commander of the Ladies Auxiliary. (Courtesy of Gino Renda.)

A powerful figure in Democratic politics, Roger Sullivan, born on February 3, 1861, served as a delegate to the Democratic National Convention in 1904, 1912, and 1916. He made an unsuccessful bid for the U.S. Senate in 1914. He is pictured here campaigning across the state. He eventually settled in Cook County where he died of heart failure at the age of 61 on April 14, 1920. (Photograph courtesy of the Chicago Historical Society.)

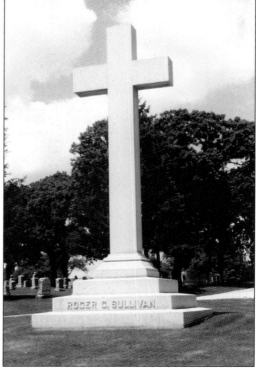

From a shoe shine boy, to high school teacher, to labor leader, to U.S. congressman, Democrat Frank Annunzio represented Chicago's Seventh and Eleventh Districts in the House for 28 years. First elected in 1965, he rose in power to serve as subcommittee chairman on the House Banking, Finance, and Urban Affairs Committee. He championed legislation that would protect the consumer from credit card debt and high interest rates. He retired his post in 1993. Born on January 12, 1915, he died on April 8, 2001, and is interred in Queen of Heaven Cemetery. (Courtesy of Joseph Annunzio.)

Celeste Lizio is a true Chicago rags-to-riches story. She came to America with her husband in the 1930s. They saved to open a restaurant where she started selling a delectable homemade pizza that put her place on the map. From those beginnings she created Mama Celeste's line of frozen foods, featuring quality homemade Italian food products. Born in her native Italy in 1908, she died in 1988 and was laid to rest in the Queen of Heaven Mausoleum. (Courtesy of the Lizio family.)

William John "Bill" Wightkin was born on July 28, 1927. From 1950 to 1957, the Detroit native was a mainstay on the Chicago Bears' offensive line. The former Notre Dame standout was elected to the Pro Bowl in 1955. Playing primarily at the tackle position, he was a diversely talented player who saw time on the defensive line and in special teams. Wightkin is interred in the Queen of Heaven Cemetery. (Courtesy and copyright of the Chicago Bears Archives. All rights reserved.)

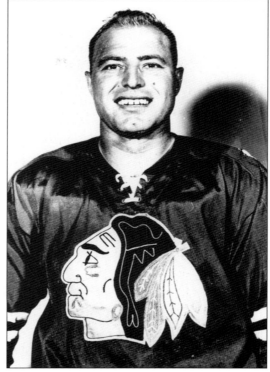

Elmer "Moose" Vasko was a member of the last Chicago Blackhawks team to capture the Stanley Cup in 1961. Born on December 11, 1935, he was a native of Duparquet, Quebec, and a member of the same minor-league team to spawn such legends as Bobby Hull and Stan Mikita. For over a decade, he was a fixture as a defensemen for the Hawks, selected as a second-team, all-star defensemen for two consecutive seasons. He died of cancer at the age of 62 on October 31, 1998, and is interred at the Queen of Heaven Mausoleum. (Courtesy and copyright of the Chicago Blackhawks. All rights reserved.)

A career player for the Chicago White Sox, John Dungan "Johnny" Rigney made his debut on April 21, 1937. He was the winning pitcher on the mound at Comisky Park's inaugural game on August 14, 1939. Two years later, he married the club's founder. He played for the Sox for 10 seasons and then served as vice-president from 1955 to 1959. He died on September 30, 1995, and his body rests in Queen of Heaven. (Courtesy and copyright of the Chicago White Sox. All rights reserved.)

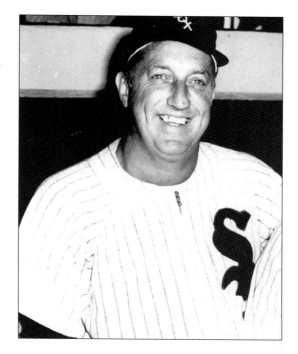

An impressionist, comedian, and actor, George Kirby made his big splash in 1948 on Ed Sullivan's *Toast of the Town*. A popular club performer with impersonations of Ella Fitzgerald and Louis Armstrong, Kirby was a staple at the Apollo Theatre and in Las Vegas. He was a regular on programs like *The Jackie Gleason Show*, *The Tonight Show*, and the *ABC Comedy Hour*. After his death on October 21, 1984, he was laid to rest in the Queen of Heaven Cemetery. (Courtesy of Jeff Bertacchi.)

Perhaps one of the sadder chapters in recent history surrounds the abduction and murder of police officer Anthony Raymond, who was killed making a routine traffic stop on October 1, 1972. His body was found 10 months later. Investigations into his murder led to a nationwide change in police communications, expanding channel frequencies to create bandwidths for the sole use of emergency responders. Over 500 policemen and most of Hillside turned out for Raymond's funeral. He was given full honors as 200 police cars made up the escort to his final resting place in Queen of Heaven Cemetery. Born on June 13, 1947, he was only 25 years old at the time of his death. (Courtesy of the Village of Hillside.)

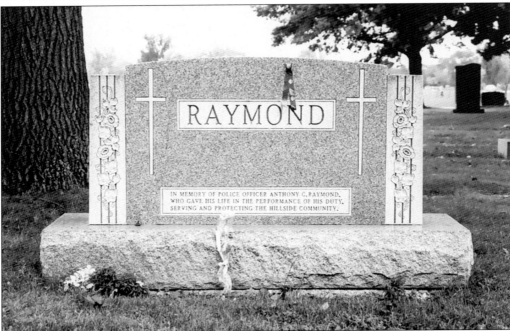

IN MEMORY OF POLICE OFFICER ANTHONY C. RAYMOND, WHO GAVE HIS LIFE IN THE PERFORMANCE OF HIS DUTY, SERVING AND PROTECTING THE HILLSIDE COMMUNITY.

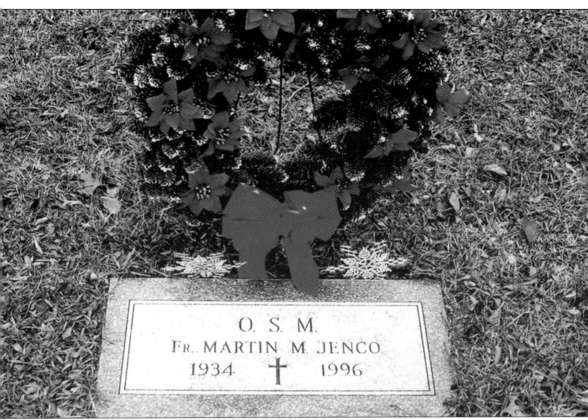

Famous as one of the hostages held in Lebanon during the 1980s, Fr. Martin M. Jenco O.S.M. is buried at Queen of Heaven Cemetery. Serving as director of Catholic Relief Services in Beirut, Lebanon, he was kidnapped by Shiite Muslim extremists on January 8, 1985. He was freed after 19 months in captivity. During some of that time, he was held in the same cell as fellow hostage Terry Anderson. Upon his release, Jenco served as the chaplain at the University of Southern California. He died of pancreatic cancer on July 19, 1996. (Courtesy of Jeff Bertacchi.)

It is one of the most beautiful family mausoleums on the grounds of Mount Carmel. Yet, it houses one of the cemetery's tragic stories. John Lavezzorio had come from very humble beginnings. His grandfather labored for only 4¢ a day in Italy. His father brought him to Chicago at the age of five, and after only one year of schooling, he was sent to work. Yet, from these poor roots, Lavezzorio worked to create an empire. He made millions in the produce industry and real estate. Unfortunately, he also suffered from depression, taking his own life in 1928. In his memory, his widow had this elaborate tomb built. It resembles a gothic church, complete with flying buttresses. The family had it copied from one they had admired in Italy.

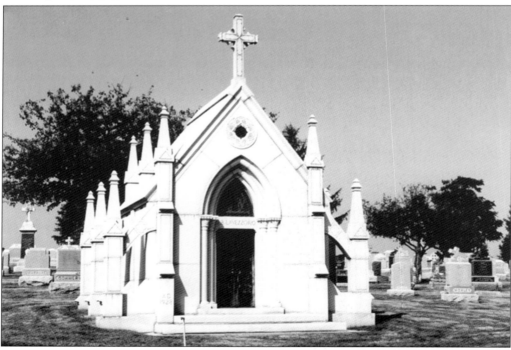

An acrobatic performer with Buffalo Bill and the Ringling Brothers Circus, Fukuzo "Frank" Hashimoto came to America in 1906 by himself as a 10 year old. Showing great potential, he had been recruited by a U.S.-based Japanese talent agency, where he was trained to perform in vaudeville theaters, outdoor circuses, and private clubs. In 1919, he met his wife Osai Sakamoto, and together they formed an acrobatic team that toured the country. Having lived a life sheltered by the trappings of celebrity and success, they did not suffer the indignity of internment during World War II, however, the anti-Japanese racism of the time ended their careers in 1941. The couple settled in Chicago in the Japanese community around Division and Clark Streets, where Frank started a new career as a restaurant chef. He died in 1986 and was buried at Mount Carmel. (Courtesy of Nancy Hashimoto.)

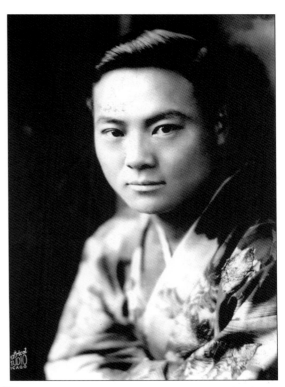

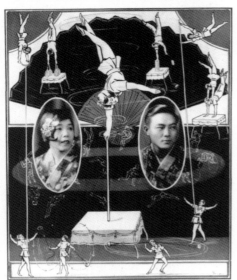

115

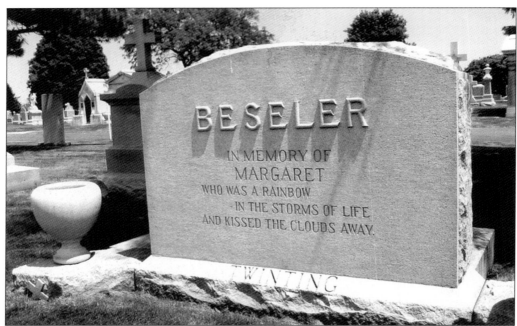

One of the most touching sentiments engraved in stone at Mount Carmel is the message that family members left in memory of Margaret A. Beseler (née Flanagan), who died on April 3, 1919. It is a reworded quote from the children's book *Pollyanna* that was written by Eleanor H. Porter and originally published in 1913.

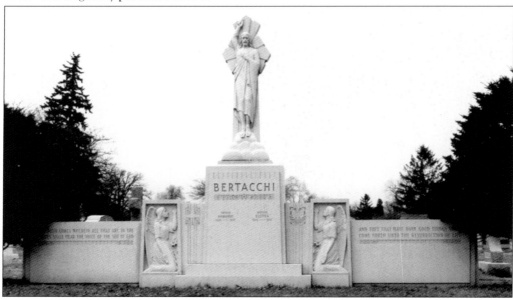

The Bertacchi family monument is one of the most impressive monuments at Mount Carmel. The Bertacchi family, who have a long established business in Hillside designing memorial monuments, erected a statue of the Resurrection on an impressively carved granite pedestal. Because of its size, presence, and artistic detail, it is perhaps one of the more memorable statues in the cemetery.

It might be argued that the monuments that evoke the deepest feelings of sorrow are those of the children, frozen in granite or marble as they were in life. Two of the most haunting monuments on the grounds of Mount Carmel are that of young Marie Serittello and Francesco Salerno. A century ago, before the eradication of many childhood illnesses, a large percentage of children did not live past their 10th birthdays. Taken from photographs, some of which are also embossed on the headstone, exists a good number of these little "angels." Tragically for the Salerno family, if one takes a closer look just to the left and right of seven-year-old Francesco's dangling feet, are also the epitaphs of two baby boys.

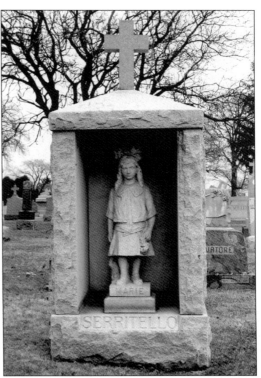

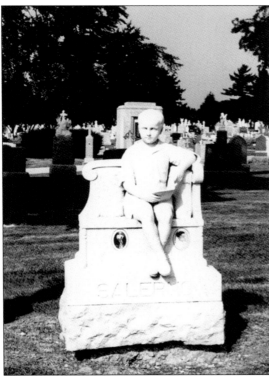

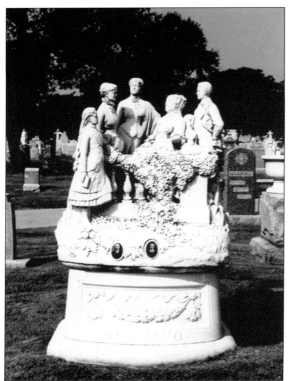

The monument to the DiSalvo family has an extremely unique feature. Carved and shipped from Italy, it depicts the entire family, seated or standing in a garden setting. The statue is mounted on a pedestal that has the ability to rotate 360 degrees around its base. This revolving feature was incorporated into the design so that the four graves on opposite sides of the statue could be graced by the family's undivided attention during different holidays and occasions.

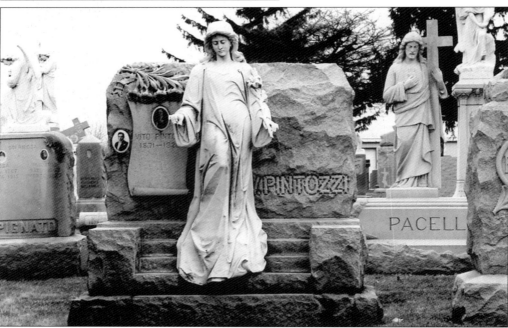

With its striking statuary and beautiful headstone carvings, the Pintozzi family monument is one of Mount Carmel's most recognizable headstones. It is one of the first statues to grace the Harrison Street entrance.

As many of the family mausoleums at Mount Carmel go, it perhaps is one of the more simple in construction, but behind it there is a touching story. When Francesco Garofalo lost his wife, Mary, in 1934, he realized that without any children or close family members, he was alone. He took his savings, and in 1936, he constructed this two-crypt tomb, so that, in eternity, he and his wife could be reunited. Looking inside the glass doors, a small shovel and bucket sit inside, just as he must have left it for the last time.

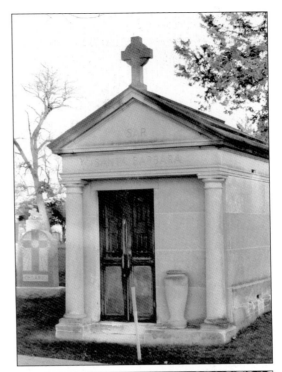

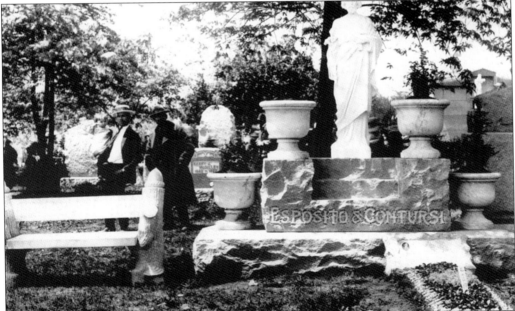

According to Italian tradition, the Sunday religious ritual also includes a visit to the cemetery to pay respects to family members who have died. This is Domenico Contursi at the family grave in Mount Carmel Cemetery in 1923. He also would have made similar visits on holidays and birthdays. (Courtesy of the University of Illinois at Chicago; the University Library, Department of Special Collections—Italian American Collection.)

Karen and Adele Biagini visit loved ones in 1983. (Courtesy of the Biagini family.)

Three generations of the family of Jesus Moreno, who died tragically in 2003 at the tender age of 16, are seen keeping a vigil at his grave in 2005.

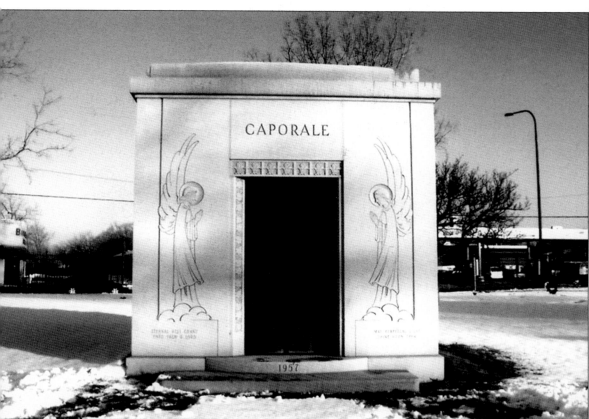

Erected in 1957, the Caporale family mausoleum was built as a memorial to honor a special set of parents. The couple's seven children pooled finances in order to build the $25,000 structure. At that time, the price would have been equivalent to a brand-new three-bedroom house in the same neighborhood. (Courtesy of Gabe Caporale.)

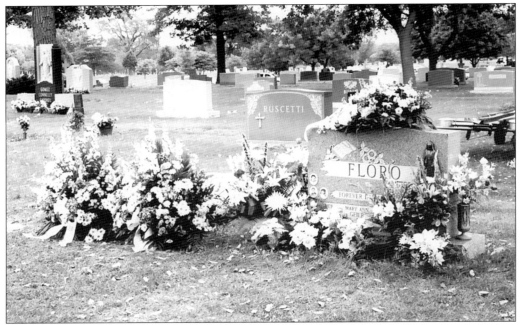

The Floro family has committed a loved one to the family plot, and numerous floral displays surround the gravesite. After the funeral, it is their custom to place flowers on the graves of grandparents, aunts, and uncles.

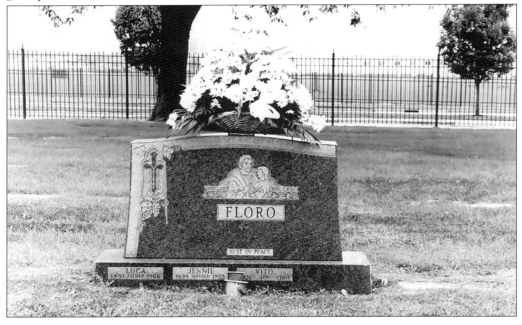

Ethnic pride is also on display in monument designs. The above image is a perfect example of a Celtic cross, a combined symbol of paganism and Christianity for those of Irish, Scottish, and Welsh descent. The image below is a statue of San Francesco di Paola. He is the patron saint of Paola, located in the region of Calabria, Italy. Many of Chicago's immigrant community came from the central and northern provinces of that region.

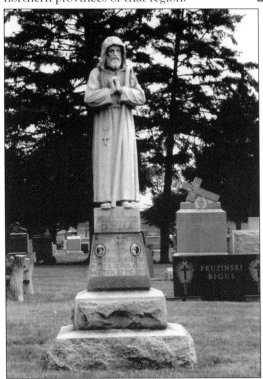

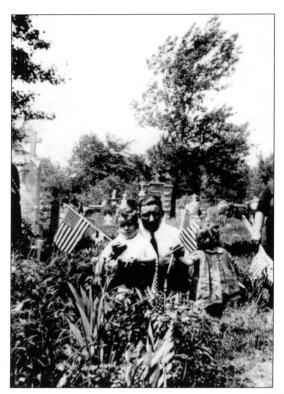

The Tortouces are visiting the grave of their young son and brother, Joseph, who died of rheumatic fever at the age of 12. Peter Tortouce is in the center with his young son Vincent. (Courtesy of the University of Illinois at Chicago; the University Library, Department of Special Collections—Italian American Collection.)

This is a Scalia family picnic at Mount Carmel Cemetery in 1935. (Courtesy of the University of Illinois at Chicago; the University Library, Department of Special Collections—Italian American Collection.)

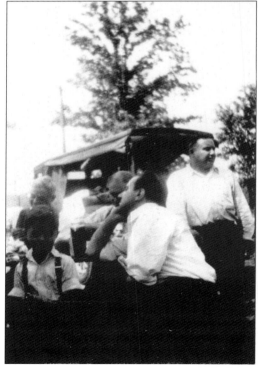

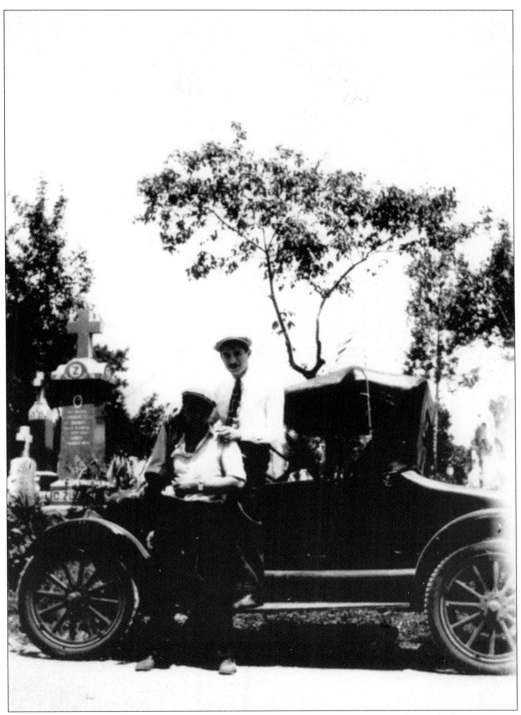

Seen here are Tom Scalia (top) and friend Mike Cutern at Mount Carmel Cemetery in 1935. (Courtesy of University of Illinois at Chicago; the University Library, Department of Special Collections.)

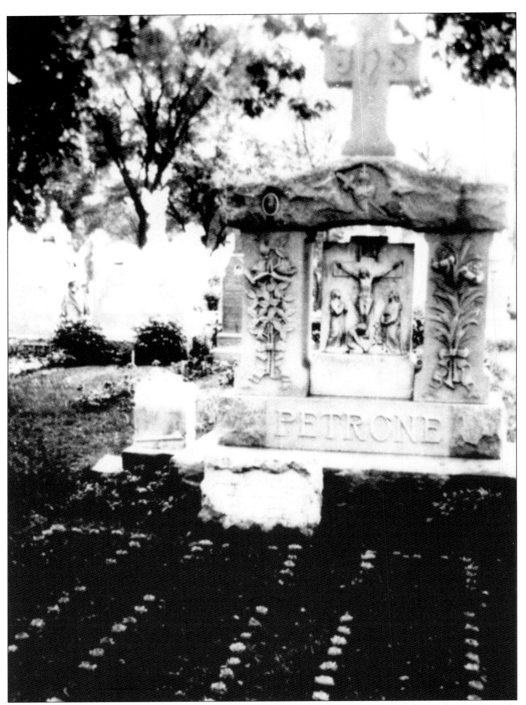

The Petrone family plot provides another example of a fading Italian family tradition. Family members used to decorate the outlines of the graves with stones, shells, or flowers. The above photograph was taken in 1939. (Courtesy of the University of Illinois at Chicago; the University Library, Department of Special Collections—Italian American Collection.)

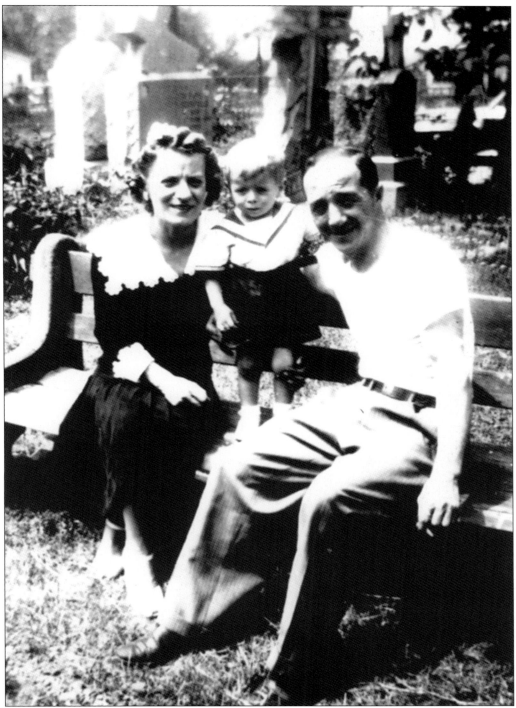

Clara Petrone, Jerry Jr., and Jerry Petrone are seen visiting the Petrone grave at Mount Carmel Cemetery in 1940. (Courtesy of the University of Illinois at Chicago; the University Library, Department of Special Collections—Italian American Collection.)

ACROSS AMERICA, PEOPLE ARE DISCOVERING SOMETHING WONDERFUL. *THEIR HERITAGE.*

ARCADIA PUBLISHING IS THE LEADING LOCAL HISTORY PUBLISHER IN THE UNITED STATES. WITH MORE THAN 3,000 TITLES IN PRINT AND HUNDREDS OF NEW TITLES RELEASED EVERY YEAR, ARCADIA HAS EXTENSIVE SPECIALIZED EXPERIENCE CHRONICLING THE HISTORY OF COMMUNITIES AND CELEBRATING AMERICA'S HIDDEN STORIES, BRINGING TO LIFE THE PEOPLE, PLACES, AND EVENTS FROM THE PAST. TO DISCOVER THE HISTORY OF OTHER COMMUNITIES ACROSS THE NATION, PLEASE VISIT:

WWW.ARCADIAPUBLISHING.COM

CUSTOMIZED SEARCH TOOLS ALLOW YOU TO FIND REGIONAL HISTORY BOOKS ABOUT THE TOWN WHERE YOU GREW UP, THE CITIES WHERE YOUR FRIENDS AND FAMILY LIVE, THE TOWN WHERE YOUR PARENTS MET, OR EVEN THAT RETIREMENT SPOT YOU'VE BEEN DREAMING ABOUT.